PRESTIGE AND EXCELLENCE

Chosen by presidents, world leaders and visionaries. Launched in 1956, it was the first watch to display the date and day in full. Available exclusively in 18 ct gold or platinum, and in 26 different languages, it continues its legacy as an icon of achievement. **The Day-Date.**

#Perpetual

OYSTER PERPETUAL DAY-DATE 40
IN 18 CT WHITE GOLD

PRESIDENT BRACELET

In the dance of neurons and circuits,
 a new partner emerges.

Not to lead,
 but to follow your rhythm.

Claude:
 AI that amplifies
 your humanity,

 turning synaptic sparks
 into constellations of ideas.

Discover yourself,
 illuminated.

ANTHROPIC.COM/CLAUDE

Party

Handcrafted Vessels in Resin
Explore the collection at tf.design

Modern since 1949. Thousands of new combinations yet to be discovered.

String shelving system, made in Sweden for 75 years. Find a reseller in your region: stringfurniture.com/find-a-store

louispoulsen.com

PH 5 FOREVER

Louis Poulsen loves recycling and upcycling. The PH 5 Retake is made from flawed PH 5s with slight irregularities or dents, using minimal resources, whereas the classic PH 5 is passed down through generations.

MASTHEAD

KINFOLK

MAGAZINE

EDITOR IN CHIEF — John Burns
DEPUTY EDITOR — George Upton
ART DIRECTOR — Christian Møller Andersen
DESIGN DIRECTOR — Alex Hunting
COPY EDITOR — Rachel Holzman

STUDIO

PUBLISHING DIRECTOR — Edward Mannering
STUDIO MANAGER — Vilma Rosenblad
DESIGNER & ART DIRECTOR — Mario Depicolzuane
DIGITAL MANAGER — Cecilie Jegsen
ENGAGEMENT EDITOR — Rachel Ellison

CROSSWORD — Mark Halpin
PUBLICATION DESIGN — Alex Hunting Studio
COVER PHOTOGRAPH — Annika Kafcaloudis
Emman Montalvan

WORDS

Precious Adesina
Allyssia Alleyne
Alex Anderson
Lamorna Ash
Benjamin Dane
Daphnée Denis
Tom Faber
James Greig
Elle Hunt
Robert Ito
Stine Kirkegaard
Tal Janner-Klausner
Hugo Macdonald
Tea Malmegård
Hannah Marriott
Kyla Marshell
Francis Martin
Ali Morris
Kabelo Sandile Motsoeneng
Emily Nathan
Rebecca Thandi Norman
Okechukwu Nzelu
Sala Elise Patterson
Rebekah Peppler
Marion Ringborg
Asher Ross
Apoorva Sripathi
Amanda Thomson
George Upton
Annick Weber

STYLING, SET DESIGN, HAIR & MAKEUP

Sofie Brunner
Tine Daring
Kelly Fondry
Caroline Gudmandsen
Niklas Hansen
Andy Kelly
Mariska Lowri
Nicole Maguire
Nadia Pizzimenti
Sara Rostrup
Stephanie Stamatis
Mads Stig
Sandy Suffield
Ronnie Tremblay
Carlee Wallace
Lynne Weare
Lisa Yang

ARTWORK & PHOTOGRAPHY

Martin Barraud
Sarah Victoria Bates
Simon Baungård
Ted Belton
Justin Bettman
Luc Braquet
Alex Huanfa Cheng
Valerie Chiang
Pelle Crépin
Marina Denisova
Jesse Draxler
Abigail Enright
Luke Evans
Lasse Fløde
Antoine Geiger
Lance Gerber
Phillip Hyunh
Cecilie Jegsen
Stephan Julliard
Annika Kafcaloudis
Alixe Lay
Frederik Lindstrøm
Christian Møller Andersen
Emman Montalvan
Miffy O'Hara
Alexander Poellinger
Adam Katz Sinding
Aaron Tilley
Emma Trim
Christina Webber
Bekah Wriedt
Xiaopeng Yuan

PUBLISHER

Chul-Joon Park

The views expressed in *Kinfolk* magazine are those of the respective contributors and are not necessarily shared by the company or its staff. *Kinfolk* (ISSN 2596-6154) is published quarterly by Ouur ApS, Amagertorv 14B, 2, 1160 Copenhagen, Denmark. Printed by Park Communications Ltd in London, United Kingdom. Color reproduction by Park Communications Ltd in London, United Kingdom. All rights reserved. No part of this publication may be reproduced, distributed or transmitted in any form or by any means, including photocopying or other electronic or mechanical methods, without prior written permission of the editor in chief, except in the case of brief quotations embodied in critical reviews and certain other noncommercial uses permitted by copyright law. The US annual subscription price is $80 USD. Airfreight and mailing in the USA by agent named World Container Inc., c/o BBT 150- 15, 183rd St, Jamaica, NY 11413, USA. Periodicals postage paid at Brooklyn, NY 11256. POSTMASTER: Send address changes to *Kinfolk*, World Container Inc., c/o BBT 150-15, 183rd St, Jamaica, NY 11413, USA. Subscription records are maintained at Ouur ApS, Amagertorv 14B, 2, 1160 Copenhagen, Denmark. SUBSCRIBE: *Kinfolk* is published four times a year. To subscribe, visit kinfolk.com/subscribe or email us at info@kinfolk.com. CONTACT US: If you have questions or comments, please write to us at info@kinfolk.com. For advertising and partnership inquiries, get in touch at advertising@kinfolk.com.

ISSUE FIFTY-FOUR

WELCOME
The Party Issue

"Too few of us, perhaps, feel that breaking of bread, the sharing of salt, the common dipping into one bowl, mean more than satisfaction of a need," the legendary American food writer M.F.K. Fisher once wrote. "We make such primal things as casual as tunes heard over a radio, forgetting the mystery and strength in both."

Rarely is the casual get-together—so commonplace among friends and family—considered powerful; by nature, these are supposed to be carefree occasions. But Fisher's call to savor the moments we spend with one another has steered this issue of *Kinfolk*, which publishes just in time for the ripple of parties that the holiday season brings. Inside, we draw on our origins as a guide for small gatherings and celebrate coming together—whether round a table, at a wedding, for cocktails or the holidays—as a meaningful pursuit.

Of course, the art of togetherness is not always entirely carefree—especially if you're the one providing Fisher's communal dipping bowl. To make the process easier, we've approached creative cooks, florists and artists for their ideas, tips and advice, creating a 64-page section that's full of inspiration for your next party. You'll find ideas for every occasion, from simple recipes for new drinks to serve on a Saturday night to advice on decorating a low-key (and low-cost) wedding. Most importantly, we asked the professionals for some expert advice on hosting, which, whatever you do, is worth bearing in mind: "How much you are enjoying yourself sets the tone for everything," says chef Anna Jones, interviewed on page 126. "People would rather come to your place and eat something super simple and have a good time than eat a fancy meal that has stressed you out."

Elsewhere in the issue, we meet A.G. Cook, the hyperpop music producer responsible for the bangers that became the life and soul of this summer's parties. On page 52, he makes a case that even the most overplayed tunes on the radio can be feats of intense creative exploration. The chef and restauranteur-turned-actor Matty Matheson shares similar vital insights from his own experiences on page 102—not least the secret to making a good sandwich. Plus, we meet a muralist, ask whether millennials have ruined weddings, tour a restored Roman villa, and check in with a curator, a baby name consultant, a comedian and much more beyond. Cheers!

WORDS
JOHN BURNS

CONTENTS

20 — 50

STARTERS
Pettiness, hope and baby names.

20	The Cost of Living	34	On the Mend
22	How to: Have Hope	36	Word: Kinkeeping
23	Odd Jobs	38	Tangled Web
24	Cult Rooms	40	Hidden Depths
26	No Wonder	42	Trivial Pursuit
27	A Step Behind	44	Alexander Smalls
28	Kill Them With Kindness	46	Object Matters
30	Lisa Gilroy	48	What Are You Working On?

52 — 112

FEATURES
From Ancient Rome to Toronto.

52	A. G. Cook	88	Zodiac
64	Wedding Crashers	94	At Work With: Elvira Solana
68	Home Tour: Villa Ventorum	102	Matty Matheson
80	New Year's Eve	—	—

"Pop music is personality." (A.G. Cook – P. 55)

CONTENTS

114 — 176

PARTY
A guide for getting together.

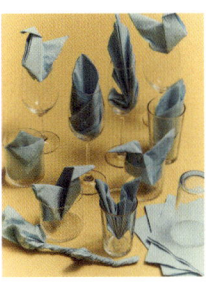

116	Whipped Butter—On Everything	154	Two Shots You Won't Regret
120	People Are Coming Over	158	Two-Bite Hors d'Ouevres
128	Thoughtful Drinks for Nondrinkers	164	Easy Twists on Classic Cocktails
136	A Modular Cake *You* Can Make	172	Recreate Your Home with Gingerbread
140	Simple Ideas for Stress-Free Florals		
148	Source Your Decor at the Grocery Store	175	Five Games for the Festive Period

178 — 192

DIRECTORY
Sage advice for the season.

178	Field Notes	186	Behind the Scenes
179	Power Tool	188	Seasonal Produce
180	On the Shelf	190	Credits
182	Crossword	191	Stockists
183	Received Wisdom	192	Point of View
185	Top Tip	—	—

HOUSE OF FINN JUHL

Finn Juhl | 1940

Photographed in *Safire* textile, color 0002 by Sahco, with legs in American black walnut.

The Pelican Chair

Finn Juhl's fascination with surrealism is clearly evident in the Pelican Chair. Among all his designs, the Pelican Chair was perhaps the most ahead of its time. The chair is crafted and hand-upholstered in Denmark and is available in textile, sheepskin, or leather. The legs are available in oak, walnut, or black-painted oak. Locate a retailer near you at finnjuhl.com.

H FJ

20	The Cost of Living
23	Odd Jobs
28	Kill Them With Kindness
30	Lisa Gilroy
36	Word: Kinkeeping
42	Trivial Pursuit
44	Alexander Smalls

Starters.

THE COST OF LIVING
How to spend your time.

It's no simple thing to live a good life. We might be able to describe the things we want—health, love, pleasure, joy—but it is usually hard to draw a line between the work and responsibilities that fill our days and the things we believe are most valuable.

A good library will show you that this has been true for most people, in most places and times. For the Greeks, the question of how to live a good life was of paramount philosophical concern. For the 19th-century American philosopher Henry David Thoreau, it was all-consuming. By the time he was 27 years old, he had retreated from his neighbors in the well-to-do town of Concord, Massachusetts, and settled in a hand-built cabin on a local pond called Walden.[1] Thoreau gambled that isolation would show him his true needs and desires. He was, so to say, off the apps and finding himself.

The resulting book, *Walden*, is popularly known as the bible of the back-to-nature movement, a proto-hippie manifesto on rustic transcendence. But those who open it expecting to find a treatise on mindfulness will be quickly rattled. Thoreau begins with a merciless accounting of his neighbors' lives, which he sees as foolish and wasteful—his chief complaint being that they spend their time pursuing material wealth and security, which most of them fail to attain, even after giving a lifetime to the cause.

The essential problem is much the same now as it was then: What we *think* we want, and what *actually* makes us happy are, in the end, not the same things. Thoreau's solution is surprisingly practical and has the tone of an economics lecture rather than the pulpit. "The cost of a thing," he writes, "is the amount of what I will call life which is required to be exchanged for it, immediately or in the long run."

When we devote ourselves to our jobs and push ourselves to acquire the outward signs of success, we often vastly underestimate the amount of "life-cost" we will pay to attain our goals. Once awoken to this cost, Thoreau saw it everywhere: the effort made to dress elegantly, curry favor among neighbors and business associates, the fear of insolvency. At one point he notes that most of his neighbors would rather appear in public with a broken leg than with patched trousers ("distressed" garments had yet to come into fashion).

A thoughtful life is a good thing, but it's also a privilege that comes easiest to those who have been given the education and freedom needed to pursue it. It's a criticism that wasn't lost on Thoreau's contemporaries, who pointed out that only a young man "from the manor born" could have the time and freedom necessary to move to a lake house for two years of thinking.

Fair enough, but the tragedy observed by Thoreau—that humans, born with the capacity for transcendent thought, sublime understanding and the joyful apprehension of just *being*, were spending their lives in monotonous pursuit of dubious prizes—has never been as relevant, or hard to correct, as it is today. The essential thing is this: to remember that you are the sole owner of your body, your span of life, your mind and your capacity for happiness. Once we become aware that a goal will not only cost money or time but exact a cost from our *selves*, we gain the capacity to break free from the trappings of success, and decide how we really want to spend our time.

(1) Getting away from it all at Walden Pond is a lot harder today than it was for Thoreau—the visitor's center has free public Wi-Fi.

WORDS
ASHER ROSS
PHOTO
DENNIS DID IT

Here's the thing about hope: You can't just wait for it to happen. Even in dark times, hope isn't something that you simply do or don't have. Like love (hope's close cousin), hope is an action, a choice that you make again and again.

So, how do you practice hope?

First, you need to make space for grief; don't push your pain aside. When we accept difficult feelings, they move through us rather than get stuck. At the same time, we can take comfort in the beauty and wisdom of the world. Nature knows how to heal itself. Ecosystems restore themselves after devastation; green shoots grow up through the ash after a forest fire. In the same way, we can create the fertile ground on which hope can grow—even small actions can be like the shoots of these first plants.

Find your own ways to create that space in yourself, where there is room for both pain and wonder. It could be through meditation or prayer, music, going for a run, writing in a journal, picking fruit from a tree, taking in the sunset by the sea or a tender embrace.

Remember that change can often happen unexpectedly. People find ways to forgive and reconnect. Wars end, regimes fall. Change can surprise you by its speed, but usually it has been brewing for a long time. A seed can wait for many years before the conditions are right for it to sprout.

There are certainly those who believe it is risky to cultivate hope. Expectation can be followed by disappointment: Some recover from illness, many will not; some relationships will not be rebuilt. We live in a world of untold human and nonhuman suffering from war and ecological destruction. But then hope needn't be an expectant faith, nor a battle cry. Hope can be an ambivalent and vulnerable choice, one that does not ignore the pain of our present reality nor deny the fear that we won't see the changes we long for; it's a choice to act as if a better world is possible, in order to make it so.

WORDS
TAL JANNER-KLAUSNER
PHOTO
MARTIN BARRAUD

HOW TO: HAVE HOPE
A feel-good approach to the future.

WORDS
GEORGE UPTON
PHOTO
BEKAH WRIEDT

ODD JOBS
Morgan Timm, baby name consultant.

When Morgan Timm posted a video with her favorite names from a vintage high school yearbook on TikTok in 2021, she never expected it would lead to a full-time job. Soon requests for more old-fashioned names turned into personalized suggestions and a business with a steady stream of clients. "A lot of people love that somebody is caring as much about their baby's name as they are," she says. "But sometimes I'm just there to listen. They want that human element of, 'Hey, this is an important decision and you're doing a good job.'"

GEORGE UPTON: What makes an old-fashioned name ready for a comeback?

MORGAN TIMM: I would say it's generally when it reaches grandparent name status, so usually around 50 years after the name has spiked in popularity.

GU: You started out by highlighting some old-fashioned names from your collection of vintage yearbooks. What other resources do you use?

MT: Usually clients tell me that they want a name that's familiar but outside, say, the top 50 names from last year. Eighty percent of the people I work with are from the US, so I'll use the Social Security database to cross those names off the list. Many will also have etymological and cultural preferences—there's a website called behindthename.com that will give you the different roots and meanings of a name.

GU: What are some of the factors you consider during a consultation?

MT: A big one is the need to find something that both parents like and meeting in the middle of their tastes. Another is whether there is a phonetic preference, perhaps because the grandparents live abroad and might have trouble pronouncing it, or just because the parents like the sound—a lot of people love girls' names with Ss and Ls and Es, for example. Another important consideration is the cultural implication of the name and whether it's going to blend into the environment that the child is growing up in. The model Nara Smith called her baby Whimsy Lou, which wouldn't work for me, living in the Midwest, but I don't think she's going to have any problem growing up amongst models and influencers!

GU: How important is it for parents to find the right name?

MT: I always say that people tend to grow into the name that they're given. You want to put thought and love into choosing your baby's name, but it's much more common to get it right than it is to get it wrong. I work with a lot of parents whose babies have already been named. They come to me because they feel like the original name is not a good fit, but by the time we've gone through the consultation, they've gotten used to it—and very few end up changing it.

—

CULT ROOMS
The pool that Verner Panton built.

Going for a lunchtime dip at the office pool is the sort of perk you might expect at a job in modern-day Silicon Valley, but for employees at *Der Spiegel*, it was already a reality in 1969. That year, the German newsweekly moved to its new headquarters in a sober, modernist building in Hamburg that, at least from the outside, reflected the magazine's reputation for serious investigative journalism. Inside, however, the pioneering Danish designer Verner Panton created a series of eclectic interiors—and a staff swimming pool in the basement—that were drenched in vibrant colors and furnished with lamps and sculptural cladding that Panton designed specifically for the project.

Like the rest of the building, the pool was, in *Der Spiegel*'s own words, a "decorative extravaganza." Panton showed that Scandinavian design need not be limited by its reputation for minimalism and functionality, infusing the pool room with his trademark space-age aesthetic and transforming what could have been a mundane recreational facility into an immersive sensory experience. A clever use of reflective enameled panels gave a sense of endless space and the grid of colorful ceiling lamps—a pattern of red, blue and orange bulbs—were reflected in the water's surface. Were it not for the pool's ladders, you would have mistaken the rectangular basin for an art installation.

The swimming pool was destroyed by a fire in the 1980s. And today, of Panton's work for *Der Spiegel*, only the retro-futuristic canteen survives; it was donated and relocated to the Museum für Kunst und Gewerbe in Hamburg in 2011. Yet—visually distinctive and exceedingly original—the pool remains Panton's most celebrated project; and something today's tech giants could only dream of recreating.

Photo: The Spiegel Publishing House, Swimming Pool, Design by Verner Panton. © Verner Panton Design AG

WORDS
ANNICK WEBER

No one knows how a 9-foot mirrored slab came to stand on a mound outside a café in Bellvue, Colorado, but we know why it's no longer there: The café's owners—who deny any knowledge of its construction—took it down, having grown tired of the disruption caused by those who came to see it. Similar objects, dubbed "monoliths," have cropped up all over the world since the first was discovered in Utah's remote and appropriately martian landscape in 2020.[1] Aliens are, of course, everyone's favorite suspects; artists of diminishing originality are the more likely culprits.

The preponderance of these unclaimed monoliths mean they are no longer mysteries in any formal sense, if they ever were, and yet the phenomenon continues to intrigue us. Perhaps part of their draw is that they tend to materialize in nature. In a city, few passersby would give a polished chrome object a second glance, assuming it to be a municipal artwork; on a hill, or in a forest, however, they stand in startling contrast to their environment. And so out we trek to visit them, ready and willing to be beguiled.

Perhaps we are attracted to such mysteries because they offer space for the belief in something beyond our day-to-day experience, be it reincarnation, the existence of a loving god or aliens with a proclivity for erecting mirrored columns. Perhaps it is for the same reason that we read novels and watch films: to experience something that stands apart from our lives. Is it a coincidence that the chief plot driver in so many popular books and movies is the same question that makes monoliths so intriguing: whodunit?

Today there are increasingly fewer mysteries in our scientific, overdocumented world. So—with even shimmering monoliths now humdrum—where can we turn to find the mystery in our lives? Perhaps the best place to start is the landscape in which they appear. Touch the earth, observe the clouds, consider the extraordinary statistical unlikeliness of evolution and chance which has led you to this exact moment, on a planet spinning at 1,000 miles an hour in a mostly uncharted universe. It makes you wonder, at least.

(1) *Monolith Tracker*—an unofficial website allowing users to report the appearance of these mysterious columns—has documented the discovery of over 200 similar, shiny structures around the world since 2020.

NO WONDER
Making the case for mystery.

WORDS
FRANCIS MARTIN
PHOTO
LANCE GERBER

Artwork: Installation view of *Specter* (2019) by Sterling Ruby at Desert X. Courtesy of Sterling Ruby and Desert X.

Have you ever thought of the perfect comeback to a cutting remark—only to find you've missed the moment? Too late, you come up with the witty retort that would have silenced your catty interlocutor; the words arrive only as you leave the party, or when you get home, or as you sit bolt upright at four in the morning.

You might be relieved to know you are not alone. In an episode of the American sitcom *Seinfeld*, George Costanza spends days trying to recreate an encounter, having missed the opportunity to respond to a remark by a co-worker. Plagued by the failure, he takes a three-hour flight in an unsuccessful attempt to make the perfect comeback.

The French call the phenomenon *l'esprit d'escalier*, or "staircase wit," a term that has its origins in an essay by the 18th-century philosopher Denis Diderot. He describes feeling so overwhelmed during a conversation at the home of an important statesman that he was only able to gather his wits as he was leaving (at that time, reception rooms were on the second floor, meaning that Diderot would have to go downstairs in order to leave). Ironically, Diderot's essay "Paradox sur le Comédien" wasn't published until 1830, 46 years after he died.

It's an idea that has equivalents in other languages: The Yiddish term is *trepverter* (step words); in German, it's *treppenwitz* (staircase wit). In a play on the idea, the philosopher Friedrich Nietzsche uses the term *treppen-glück*—which translates to "staircase happiness" to describe the experience of only being able to enjoy an event, or even a whole period of your life, after it has happened.

What are we doing when we think up the perfect line long after it's needed? Ultimately, it's not revenge; it's redemption. It's as though it is not really our rhetorical adversaries that obsess us—or the shame and frustration we felt in struggling to find a comeback—but ourselves. We know the moment has passed, but something in us—somewhere between pettiness and perseverance—refuses to give up.

WORDS
OKECHUKWU NZELU
PHOTO
MIFFY O'HARA

A STEP BEHIND
On the wit of the staircase.

KILL THEM WITH KINDNESS
What makes a murder cozy?

WORDS
REBECCA THANDI NORMAN
ARTWORK
JESSE DRAXLER

A number of recent think pieces have heralded the return of the "cozy murder" genre but perhaps a less interesting, more accurate, take is that the genre never really went away. The Kenneth Branagh–led Agatha Christie adaptations and the *Knives Out* films are only a few of the many recent examples, while bestselling authors like Anthony Horowitz, Richard Osman and Janice Hallett have all paid homage to its tropes and tells.

Contrary to what its many detractors may say, a cozy mystery can be serious literature and feature motifs and larger messages; it may even let you discover something about yourself. While gritty noir thrillers and procedurals tend to focus on the ins and outs of forensics and the crime itself, in cozy mysteries, the story can hinge on the murder, but it's not the entire reason for its being. The murder is the entry point for the reader, but not the exit wound, so to speak.

"Cozy murder mysteries, to me, are murder mysteries that take place in a world that's ultimately safe and fun. Crimes happen, but they're the aberration, not the norm, and whatever goes wrong can be fixed," explains novelist Robin Stevens, the creator of the popular middle-grade series *A Murder Most Unladylike Mystery*.

Kemper Donovan, another cozy mystery writer and the host of Agatha Christie–themed podcast *All About Agatha*, takes another perspective: It's all in the participation.[1] "If we're talking about 'fair play' mysteries, which can be read actively and solved via clues, there is a satisfaction to these novels that a reader cannot get from any other genre," he says. "The agency, or promise of agency, these books provide, is a source of significant enjoyment, perhaps especially to a readership that finds itself... disenfranchised in some way."

Much has been said over the years about our obsession with true crime, cozy crime, any kind of crime; but is it really a big mystery? Murder is terrifying and taboo, yet it undeniably exists in our world and these stories help us come to terms with it. While procedurals and true crime feed a certain curiosity for the grim details (while simultaneously offering a way of distancing ourselves from those details), cozy mysteries resolve anything unsavory and out of the ordinary. They reveal what it is we really yearn for: truth, justice, humor and—most cozy of all—hope.

(1) The writer of this article, Rebecca Thandi Norman, has her own Agatha Christie–themed podcast called *Tea & Murder*, which she describes as "the opposite of true crime."

LISA GILROY

WORDS
ROBERT ITO
PHOTOS
EMMA TRIM

The new queen of comedy.

To hear her tell it, Lisa Gilroy's rise in the comedy world is the result of a series of happy and often unexpected events. One day, she's hosting a children's show where the cast pulls pranks on unsuspecting high school students; the next, she's appearing in the Netflix series *Glamorous* alongside Kim Cattrall.

Now Gilroy is making repeated forays into American TV, including the new Taika Waititi–directed series *Interior Chinatown* and the comedy series *The Studio*, created by Seth Rogen. Speaking from a café in the Larchmont neighborhood of Los Angeles, she shares how she made the move from her hometown of Edmonton ("I am legally obligated to tell you the biggest mall in Canada exists there"), why she found success on YouTube, and the first time she got a really big laugh.

ROBERT ITO: You grew up in Edmonton. Is there an Edmontonian sense of humor?

LISA GILROY: I guess, like any Canadian humor, it will be riddled with "sorry's" and "I love you's." It's just maybe a bit on the nicer side, which is great. That's totally my flavor.

RI: Who were your comedy idols?

LG: I watched a lot of *Saturday Night Live*. When I was growing up, it was Maya Rudolph and Kristen Wiig and Amy Poehler and Tina Fey. That was when the girls were really having their time.

RI: Do you remember the first time you got a big laugh?

LG: Yes! It was in seventh grade. I got cast in a play, which was huge because I normally wouldn't be trusted to learn lines and show up to rehearsals because of my attention problems. But my teacher really believed in me, and so he put me in this play called *The Godmother*, which was a parody of *The Godfather*. I played the housekeeper of a motel where all these mafia bosses were hiding out from the cops. The motel was called The Heat is On, and the mob bosses were always asking about turning up the heat—it was too cold in there or something—and my line was "The heat is on. The heat is *always* on."

RI: I don't think I get it.

LG: Yeah, I don't really get it either.

RI: But it got a big laugh, and you were hooked?

LG: Yes, definitely. Everybody laughing at the same time? Can you imagine? Especially as I was a child who was universally hated by authority figures. It was the first time I experienced that feeling of power. I kept taking drama as my elective, and then in college I studied to become a teacher so I could teach drama. I figured being a drama teacher was the closest I could get to just goofing around and being playful all day.

RI: And then you got a hosting gig on *Undercover High*.

LG: That was my first on-camera job and it was a blast. We would have a cosmetologist come in and teach the kids how to do a face mask on someone, and then the actress would break

out in this terrible rash. Just silly stuff. One time we brought in a llama to the cooking class and we were basically like: You are going to execute this llama and cook it. The kids were so upset. A lot of them cried. That one didn't end up airing.... I thought it wouldn't lead anywhere. I was living in Edmonton at the time, crashing at a family friend's place. I kept thinking: Once this is done and my free ride is over and people stop handing me these wonderful opportunities, I'll go back to teaching and then I'll die. That was my big two-step plan.

RI: Did you ever think about not doing comedy at all?

LG: The pandemic was a really hard time. I keep a little spreadsheet on my computer of all the auditions I've done, and there was a stretch of, like, 57 auditions without booking anything. Things were getting pretty dire, and then the pandemic turned everything to self-tape. You would hobble to the kitchen, put your little curtain up, film your thing and then throw it into the ether, which essentially felt like throwing it into a garbage can. But that's what got me started making videos for the internet, which is part of what led me here today. Because then people started following me out of nowhere; suddenly lots of people were watching my videos and sharing them.

RI: How important is it to use social media platforms as a comedian? Is it something you just have to do now?

LG: I don't know. I feel like I've been really lucky. I'm still kind of riding that momentum of having made all that when I had nothing else to do during the pandemic, and I was making two or three videos a week. Some of those are still banging around on the TikTok algorithm and I get views all the time. Now I feel like I have some momentum in the TV world,[1] knock on wood, but maybe when that dies down, I'll start making some weird videos again. That'll be my first cry for help.

RI: What are you working on now?

LG: I did *Interior Chinatown*—I get to play a detective and kick down doors and chase perps and all that stuff. The last thing I played was an influencer on *Glamorous*, so it couldn't be more night and day.

RI: Do you have a dream role?

LG: I would like to play something disgusting, something gross, like that guy in *The Goonies*. The kids go hunting for the lost pirate treasure and they find Sloth deep in the caves. He's being held there by his mean older brothers and the kids rescue him. He's a misunderstood monster.

RI: Do you see comedy as a calling? Do you think you've been called to be a funny person?

LG: I'm really lucky to have made a career out of this. But I think in any job I would have found a way to be playful and fun with it. That's why I was leaning toward being a drama teacher, because there are some jobs that make more sense than others to be playful and fun and goofy. But I'm pretty sure even if I was a brain surgeon, I'd be doing bits (and maybe I'd be fired immediately!). But I just think if that's who you are, if you want to have fun and be funny, there's lots of ways to do it.

(1) Gilroy has been widely praised for her work in the word-of-mouth Amazon Prime show *Jury Duty*, in which she plays Genevieve Telford-Warren, a highly memorable and multitalented social media brand ambassador/DJ/actor/model/lash technician. Writing in *The Atlantic*, TV critic Shirley Li called it "one of the funniest performances I've seen on TV this year."

ON THE MEND
Celebrating the aesthetics of repair.

WORDS
HUGO MACDONALD
PHOTO
LUKE EVANS

Italian designer Martino Gamper drew bemused crowds during Milan Design Week in 2014 when he showcased different repair skills on the street in front of La Rinescente, the elegant department store. The exhibition, *In a State of Repair*, was equal parts performance, public service and statement, with Gamper demonstrating how various broken goods (ranging from bicycles and radios to clothing and musical instruments) could be resurrected. It was more intriguing, edifying and memorable than any new chair or lamp launched during the fair.

The decade since has seen a cultural embrace of repair. The pandemic gave us time to rediscover handy skills while the evident perils of overconsumption, combined with repeated cost-of-living crises, mean that more of us are mending and making do before buying new. Today, we celebrate repair in lofty exhibitions and reality TV series, kintsugi kits are sold on Instagram and visible mending classes are held in chain clothing stores.

A repaired object—whether a rebound book, a patched pair of jeans or a rehabbed building—gets a new chapter in its story that we have helped to write, and honoring this biographical process gives repair an anthropological power. David Chipperfield's restoration of the Neues Museum in Berlin, for example, is compelling for the confident contrast between what is new and what remains; the building has been respectfully enhanced by a repair that is quietly celebratory, neither apologetic nor performative. We are coming around to the notion that repair has its own beauty and relationship with time; it is not so much about harking back to a better past or fixing a breakage in the present, as it is about scribing a future.

It stands to reason that the act of repair encourages us to engage with our buildings, clothing and belongings on a deeper level. As with people, when an object is broken, we get to see beneath the surface and its vulnerabilities are revealed. And the relationships we build with our things through repair have care at their core: We have invested something of ourselves in the act of mending and so we leave our mark—perhaps even with blood, sweat and tears.

(1) Kintsugi is a traditional Japanese technique that mends broken pottery using a lacquer made from the sap of the urushi tree that is dusted with powdered gold, silver or platinum, accentuating the fractures.

WORD: KINKEEPING
The glue holding families together.

Etymology: Kinkeeping, a portmonteau formed from "kin" (meaning relatives) and "keeping" (meaning the charge, care or oversight of another person of thing).

Meaning: A viral TikTok video by American teenager Molly West led to a surge of interest in kinkeeping at the start of 2023, but the concept first began cropping up in academic writing on gerontology in the late 1960s. In 1981, Canadian sociologist Carolyn J. Rosenthal presented her paper "Maintaining Intergenerational Relations: Kinkeeping," in which she fleshed out the various characteristics and responsibilities that demarcate the role. She explained that a kinkeeper holds together their relatives across time and space via activities like telephoning, arranging family gatherings and providing mutual aid.[1] Kinkeeping tends to become more formalized in response to "a specific event perceived to threaten family continuity," Rosenthal suggested, like the death of an immediate relative. In other words, kinkeepers are those in battle against the inevitable entropy of nuclear families.

As with other familial roles, the kinkeeper is not born into the position, but rather learns to embody its attributes. Rosenthal noted that it is passed down through the generations, usually through the matrilineal line. Though some might posit that family chat groups have become substitutes for (or have rendered unnecessary) the role, there are still those who take a more proactive stance in such groups.

In her video, West called kinkeeping "the unpaid labor that women are *assigned* subconsciously as a gender." It is certainly the case that more women than men fulfill the role, but to suggest that it is assigned (even subconsciously) refuses women any agency in such a decision. To hold one's family together, and so perhaps to hold one's family to account, can also be a way of attaining and asserting authority within such dynamics. Of course, kinkeeping can be rewarding; it may even be a pleasure, but it would be remiss to ignore the pressures and frustrations associated with such a role. After all, a kinkeeper could easily come to realize that, were they to abdicate from their responsibilities, their family might begin to drift apart, and might even come to resemble a group of strangers.

(1) Kinkeeping can also make family moments feel "special"—the magic-making that results from proactive caregiving, like creating or carrying on family traditions, buying gifts and decorating for birthdays and holidays.

WORDS
LAMORNA ASH
PHOTO
ALEX HUANFA CHENG

TANGLED WEB
A postmortem of the internet.

WORDS
DAPHNÉE DENIS
PHOTO
ANTOINE GEIGER

In May 2024, British musician FKA twigs announced that her virtual counterpart, "AI twigs," would soon take over her social media posts so that her human self could better focus on her craft, away from the never-ending cycle of online content-making. She was testifying before the US Senate about the dangers of unregulated artificial intelligence. As she highlighted how musicians could use AI as a tool, the singer-songwriter revealed the existence of her own deepfake, which she had trained to mimic her personality and tone of voice. On YouTube, below a video excerpt of her testimony, one user asked: "Did anyone else think that *she* was the AI version in this video and not actually herself?"

This comment sums up one of the Web's favorite conspiracies: that the internet is defunct, and we have gone to hell. The "dead internet theory" proposes that the World Wide Web passed away sometime between 2016 and 2018, when humans online were replaced, or at least vastly outnumbered, by bots and artificial intelligence. This, so the theory goes, is all part of a plot devised by the US government and Big Tech companies to "gaslight the entire human population." And while the last quote may elicit eye rolls (there is no proof that the rise of automated activity online is part of a global scheme to manipulate people), one would be foolish to dismiss the internet's rumored passing altogether.

The few real humans left online may have noticed something is off. On X, formerly Twitter, which Elon Musk swore to rid of bots with a premium subscription service, posts denouncing the proliferation of AI-generated tweets are generally met with swift responses from bots answering one another. Not to mention, manipulation *is* happening: Content farms flood the web with low-quality automated text-to-image posts that sway our conversations online. Social media platforms are open about creating AI influencers to push advertisements onto their real followers. And for almost a decade, studies have confirmed the influence of Russian bots on Western elections.[1]

"[The dead internet theory] is a useful label for the eerie feeling that the internet that we knew and loved, *by* humans and *for* humans, is dead," Jake Renzella, a lecturer and director of computer science at the University of New South Wales in Sydney, says of the phenomenon. He points out that more than half of all internet activity, meaning comments, likes, posts or articles, is already bot- or AI-generated. That number will be closer to 90 percent by 2026, according to a study by Europol, a European law enforcement agency. This means that not only are we being targeted by AI-generated clickbait, but that the clickbait itself is gaining AI-generated likes and comments, blurring the distinction between human engagement and fake digital interactions.

So is it time to mourn our lives online? It depends, Renzella says: "Perhaps, the internet of the future will be more geared towards private spaces with select friends and family. Perhaps, we will have verification built into social media to protect against automated content and accounts." The internet was born in the 1990s. It is probably too young to die just yet, but it has certainly taken on a life of its own.

(1) In May 2024, Avril Haines, the director of national intelligence, told the Senate Intelligence Committee that Russia was the most active threat to the recent US election: "Russia relies on a vast multimedia influence apparatus, which consists of its intelligence services, cyberactors, state media proxies and social media trolls."

HIDDEN DEPTHS
The psyche behind secret spaces.

Have you ever looked at someone's pocket and wondered: What's in there? A slight sag in the fabric, an unusual contour, a clink of metal offering a tantalizing hint. Perhaps the pocket is loosely guarded with a buttoned flap or a zipper, symbolic but weak measures of security that nonetheless focus the intrigue. The object in question would be easy enough to reveal, but it remains just out of sight and, as a result, takes on an oversize significance.

Far more than just a practical space to store coins, a phone or keys, the pocket, when seen in this way, becomes a place of potential discovery. However securely these hidden spaces might guard their clandestine objects, they also seem to invite intruders to look for a way in. At a conference on "Pockets, Pouches, and Secret Drawers" at the University of London in 2021, art historian Carolyn Sargentson explained that pockets, hidden chambers in furniture or covert rooms in buildings beautifully illustrate the enigma of secrets. "A thing concealed but not known about," she said, "isn't a secret at all; it's simply a thing concealed. For it to become a secret its existence must be known in some way. Then, and only then, does it have currency and agency as a secret. Once the knowledge of the secret is out, the search for access |to| it can begin."

Scholars of hidden spaces highlight their deep cultural significance, explaining that they don't merely protect the things we value from prying and theft; they also thinly veil our hidden depths, what philosopher Samuel Talcott calls our "secreted selves." Talcott uses this term to explain that "the self is always present in the material world, though secreted away, as if in an unfathomably deep and inaccessible pocket of the physical machine."

We all project an incomplete—or edited—picture of our inner lives to the world, holding back prejudices, uncertainties and inadequacies to all but our closest confidants. Those secrets, it seems, are essential to constructing a sense of self. Maybe that is why we find a delightful riskiness in hiding things of great value in plain sight—in a carved-out book on the living room shelf, in a double-bottomed sock drawer, in an ornamental box under the bed, in a trouser pocket. These artfully hidden spaces make our most treasured objects more than merely things concealed; they become invitations to discover our deepest secrets.

WORDS
ALEX ANDERSON
PHOTO
ALEXANDER POELLINGER

STARTERS

TRIVIAL PURSUIT
In defense of being petty.

WORDS
JAMES GREIG
PHOTO
XIAOPENG YUAN

We are told that it is toxic, immature and even self-destructive to sweat the small stuff, but can pettiness ever be justified? After all, deprived of more substantial avenues of seeking redress, clinging on to minor grievances and attempting to settle the most trivial scores might be your only way of defying authority or delivering a much-needed lesson. Planting Japanese knotweed in the garden of a landlord who wrongfully overcharged you; writing a poison-pen diatribe on Glassdoor about a former employer with a penchant for making sexist jokes; leaving your fortune to a charity that provides luxury grooming services to cats instead of to your ungrateful children.[1] Might these actions, however petty, be a way of dispensing justice in an unjust world?

The prevailing idea in popular psychology holds that forgiveness is something you should do for *yourself*: The greater the offence, and the less deserving the recipient, the more therapeutic it will be to let it go with a saintlike grace. So if your neighbor runs over your cat, or your husband leaves you for your sister, it may indeed serve the healing process to exorcise all bitterness and arrive at a point where you can finally declare—with only a modest amount of self-deception—that there are no hard feelings.

But then, such serious matters are unlikely to lead to pettiness, which is, by definition, a preoccupation with the trivial and inconsequential. Of course, we shouldn't spend our lives consumed by fantasies of revenge just because someone made an offhand comment at a party years ago. But there's usually no harm in nurturing half-hearted grudges and vague dislikes. Imagine you discover that a selfish ex is going through a messy divorce, or a duplicitous former friend's new book has been met with poor sales and tepid reviews—you would be forgiven for feeling just a little gleeful as you insist that you sympathize with them and wish them all the best. It's not harming anyone, it doesn't change anything and it would be absurd to think we can police ourselves out of having any unpalatable emotions.

If we are going to be petty, it is far better to admit it than to dress it up as something more high-minded. When pettiness is something to which we can readily confess, as neither an appealing trait nor an especially damning one, it becomes not synonymous with real cruelty but a barrier against it.

(1) In May 2024, California resident Etienne Constable was ordered to hide his boat behind a six-foot fence per city code. As a protest, Constable commissioned his neighbor, artist Hanif Panni, to paint the fence with a defiant new eyesore: a photorealistic mural of his boat.

ALEXANDER SMALLS

WORDS
KYLA MARSHELL
PHOTO
JUSTIN BETTMAN

The opera singer turned trailblazing chef.

"I spoke two languages as a child—food and music. And I was fluent in both." Chef and restaurateur Alexander Smalls might have had an unconventional transition from Grammy- and Tony Award–winning operatic tenor to fine-dining pioneer, but his second career in food was in him all along. Originally from Spartanburg, South Carolina, he's made his home in New York City, where over the last 30 years he's opened five successful restaurants grounded in Black American and African diasporic cuisine. He has recently released his fourth cookbook, written with food justice advocate Nina Oduro, *The Contemporary African Kitchen*, the first of its kind to focus exclusively on African cuisine by chefs based across the continent.

KYLA MARSHELL: You've previously shared that a rejection from the Metropolitan Opera inspired you to become a chef full-time. What's that story?

ALEXANDER SMALLS: It was very hard to crack the big houses like the Met. I was waiting for them to offer me one of the major parts, but all I got was chorus and small character roles. I'd done the work. I had the pedigree and the credentials. There was nothing standing in my way, as far as I was concerned. And then I realized, well, yes, it's your skin, and that will always be what it is.

KM: How did you respond when that happened?

AS: I went home, drank a bottle of red wine and kind of cried myself to sleep. But I woke up the next morning and decided that I was going to open the first fine-dining African American restaurant—I was going to put all my energy and focus into my other love, which was culinary. Eighteen months later, I was building Café Beulah, which essentially started the movement of the modern, contemporary African American restaurant.

KM: Why was it important to you to create such a space?

AS: Fine dining is not a cuisine—it is a concept. You cannot tell me that my grandmother's brown pan gravy is not worthy of the French grandma's heavy cream and butter sauce. If French food can become fine dining, so can African American. So can the food of the African diaspora. That lit the fire. That became my mission. Five restaurants later, a 22,000-square-foot African dining hall in Dubai (the first in the world), four cookbooks and a children's book coming out in January—I made the point.

KM: How did you come to focus specifically on African cuisine?

AS: I started out talking about African Americans, but when you understand who you are as a Black person, we're African, and you embrace that and the whole thing becomes your mission. Alkebulan [the African food hall Smalls curated for Expo 2020 Dubai] really started as a plan for the Harlem Food Hall. I wanted to represent traditional African food and its own evolution to the contemporary African table. The pandemic happened and that dream kind of went out the window, but the idea ended up on the desk of Her Excellency Reem Ebrahim Al Hashimy. Her response was, "Can we make this the African Food Hall?" I brought in chefs from Kenya, South Africa, Cameroon, Ghana and Nigeria. And then it was a collective.

KM: What do you hope to achieve with *The Contemporary African Kitchen*?

AS: The book is an extension of my need to keep speaking in the space; to be a champion and a warrior for the diaspora. The whole premise of *The Contemporary African Kitchen* is to share and teach non-African chefs and potentially non-Africans how to embrace, understand and enjoy this heritage, this legacy of amazing food.

OBJECT MATTERS
In praise of painted wallpaper.

WORDS
ANNICK WEBER
PHOTO
STEPHAN JULLIARD

More fashion, furniture and decorative finishes were made for Marie Antoinette than for any other queen of France. This includes lavish wallpaper adorned with freehand depictions of exotic birds, whimsical flowers and Orientalist landscapes by highly skilled artists for her private quarters at Versailles. You could call it the "let them eat cake" school of decoration, but these creations are far more than a sign of extreme wealth and the queen's disconnect with the Third Estate; they are works of art.[1]

It's no coincidence that many of these motifs were Eastern-inspired. Besides being highly fashionable at the time, the style, known as chinoiserie, reflects the origins of hand-painted wallpaper itself. The Chinese were the first to hand-paint intricate nature-themed designs on rice paper and silk, which, by the 17th century, had begun to replace decorated wooden paneling in stately homes in Europe. The high absorbency of these materials significantly enhanced the precision of the artist's drawings, allowing for a greater level of detail in the brushstroke, more vibrancy in the colors and a richer texture. As far as interiors go, the labor-intensive craft was rivaled only by the crystal chandelier as the quintessential symbol of sophistication.

Wallpaper was democratized with the advent of machine printing during the Industrial Revolution, but a tradition of painting by hand has survived. Heritage hand-painted wallpaper companies including Pierre Frey and de Gournay now coexist with a new generation of designers and artists like Elena Carozzi, who are eschewing computer-generated patterns in favor of the irregularity of freehand techniques. Sold at hundreds of dollars per yard, every piece is a testament that nothing remains more exquisite than the human gesture.

(1) There is no evidence that Marie Antoinette actually said *"Qu'ils mangent de la brioche."* The earliest known source connecting the quote with the queen was published more than 50 years after her death in the French Revolution—in an 1843 article by the French writer Jean-Baptiste Alphonse Karr, who himself was writing to disprove its association with her.

WHAT ARE YOU WORKING ON?

WORDS
GEORGE UPTON
PHOTOS
LUC BRAQUET

Véronique Nichanian on the latest Hermès collection.

A lot has changed in men's fashion since Véronique Nichanian was appointed to head the menswear division at Hermès in 1988. For one, men were still expected to wear a suit and a tie. "It was all very limiting," she says in her office at Hermès' headquarters in the center of Paris. "But I've been talking about sensuality since I started, which was not a word people were using in the '80s or '90s!"

Thirty-six years on, and now the artistic director of Hermès' men's universe—a role that includes the creation of two ready-to-wear collections a year as well as shoes, watches and accessories—Nichanian has carved out a space for sensuality, both at Hermès and in menswear more generally. And as her latest collection with the *maison* demonstrates, she's never short of new ideas.

GEORGE UPTON: What drew you to menswear?
VÉRONIQUE NICHANIAN: It was by accident, really. I studied womenswear and haute couture, but by chance Nino Cerruti [the founder of fashion house Cerruti 1881] took me on as an assistant.[1] I discovered that men's fashion can actually be more expressive than womenswear when it comes to the small details or the research that you put into fabrics, the way it feels on the skin. That's why I'm so happy at Hermès—it's a house that really cares about material.

GU: How has men's fashion changed since you started out as a designer?
VN: Men are now able to express themselves more in the way they dress—they are open to different colors, different materials. I was looking at an old collection the other day and saw a red cashmere coat that I'd designed. I remember at the time somebody had said "Who is going to wear a red cashmere coat?" It was a bestseller. With Hermès, I hope I've helped to make the house less classic and more about the way a man *feels* in the clothes. It's all about lightness and comfort.

GU: What are you working on at the moment?
VN: The next collection [for F/W 2025]. We're coming to the exciting part, where we choose the fabric and start to refine the designs with the team. And we're also launching the Spring/Summer collection, which was inspired by a particular moment: being on the beach as the sun goes down over the sea, a light shirt floating in the wind. It has this very casual, sunny spirit.

GU: Has it ever become routine, designing a new collection?
VN: Not at all! I hate routine. Maybe that's why I like this job so much—every six months you have to start again. It's all still exciting to me. I always say that there are so many different Hermès men and that it's fun to imagine their life, how they

live, how they work, how they travel. When I start to get bored, I will stop, but that's not happened yet.

GU: Where do you tend to take inspiration from?

VN: It often starts with colors or fabrics—I'll make a color card, which in this case drew me to water, to the sea. But it could be an exhibition I've seen or somewhere I've traveled to or someone I've met on the street. Sometimes I do sketches but often it's just in my head and I'll explain my ideas to the team—it depends on my mood. I don't have a crystal ball or a marketing plan!

GU: Have you ever been tempted to start your own fashion house?

VN: It's happened twice that people have come and asked me to work on my own projects, but I don't have an ego problem, I don't need to see my name big like that. I want to do what makes me happy and what makes people feel good. When I started at Hermès, [the chairman at the time] Jean-Louis Dumas gave me carte blanche—no one has ever asked me to design anything. Now I'm working across the entire men's line, I feel like the conductor of the orchestra, organizing everyone to articulate a vision of what Hermès men's is today. It's complete freedom.

GU: Where do you see menswear going in the future?

VN: Following the pandemic, we've seen a blurring of the formal and informal, but also between menswear and womenswear, because men and women are now living the same lives. I love this porosity—we all want clothes that are practical and charming yet chic and sexy at the same time. It's a very exciting time!

(1) Nino Cerruti also gave Italian designer Giorgio Armani his big break in fashion, hiring him as a designer in the mid-'60s.

"I hate routine. Maybe that's why I like this job so much —every six months you have to start again."

52	A. G. Cook
64	Wedding Crashers
68	Home Tour: Villa Ventorum
80	New Year's Eve
94	At Work With: Elvira Solana
102	Matty Matheson

Features.

WORDS TOM FABER PHOTOS EMMAN MONTALVAN STYLING CARLEE WALLACE

A.G. COOK

THE HYPERPOP HITMAKER BEHIND BRAT SUMMER.

"You gon' jump if A. G. made it!" Whenever the British singer-songwriter Charli XCX performs her song "360" live, the crowd, waiting for this line, launches themselves into the air as soon as they hear it. The lyric, from the opening track to Charli's smash album *Brat*, refers to her ride-or-die collaborator, A. G. Cook, who produces much of her music and is a key creative consultant for her brand. She knows, as her fans do, how much of the glorious, unhinged fun of her music—and the success of *Brat*, which became a cultural phenomenon over the summer of 2024—is thanks to Cook's magic touch.

Cook says he knew the music on the album was good but the fevered intensity of its reception still took him by surprise. "I don't think anyone expected it to go so mainstream," he says. It swept across the world, from the grungiest nightclubs to the highest echelons of global politics. Just days before this interview, the X account for Kamala Harris' presidential campaign adopted the shade of slime green now synonymous with the album's cover after a deluge of memes had compared Harris' attitude with Charli's. "That stuff was just unreal," Cook says, laughing. "It sort of makes sense, but it's totally bonkers."

Perhaps he shouldn't be surprised. *Brat*'s success is only a fraction of his résumé. As the founder of the era-defining record label PC Music, Cook has been infiltrating the pop mainstream for over a decade. His crew of collaborators has evolved from fringe experimentalists to in-demand talent, tapped by artists including Beyoncé, Dua Lipa and Lady Gaga. Everything about Cook's career is intense, from the sheer volume of his output to the hyper-saturated sound of his music. Yet, speaking over a video call from his home in Los Angeles, light flooding through the window behind him, he just looks like a laid-back, normal dude. The only notable things about his appearance are his signature round glasses and shaggy mop of brown hair. As a top-rated YouTube comment on one video says: "A. G.

Cook looks like all of the members of the Beatles at once."

Speaking with him feels like chatting to a genial scholar of pop music. A single question sets Cook off on a long, winding response where he drifts through a series of freewheeling tangents, asking himself questions and answering them along the way. When asked exactly what made *Brat* such a success, for example, he has such a detailed and articulate answer that you almost expect him to produce a PowerPoint presentation. He talks about how long they spent getting the songs right, the careful marketing campaign, but most of all how the record resonated with fans because of its honesty. "We were trying to make this the most *Charli* Charli album yet; to be super-transparent, musically and lyrically," Cook says. "Because pop music *is* personality."

He spends a lot of time thinking about what pop music is, or isn't, or might be. This was the overarching question that governed the approach of his pioneering label, PC Music. Cook started the project in 2013; he was 22 and had just earned a music computing degree from Goldsmiths, an arts college in London that has a reputation for progressive thinking. While studying electronic music from the 20th century, he observed a dichotomy in the literature between acoustic music, played on "real" instruments, and computer music, which was deemed mathematical, experimental and inhuman. It seemed like an outdated paradigm. "I was seeing people using GarageBand, Skype, whatever early social networks, and thinking: everyone's got a computer, this is no longer some alien thing," he says. "We're all messing with this stuff. The laptop is like a new folk instrument. We all have it, it's at our fingertips." Cook wanted to challenge this older way of thinking. "And I was really convinced that pop music was the right battleground for that."

Having gathered together a set of like-minded artists, PC Music began releasing a dizzying array of music under a variety of aliases. Often it was unclear who was an avatar and who was a real person, who was singing and who was lip-synching, as they played with the idea of what a pop persona could be for the internet generation. A good introduction can be found in the label's three compilations which collect some of their best tracks. Listening to them back-to-back is an exhausting and exhilarating experience, as if you've fallen inside the malfunctioning mainframe of the pop machine. The songs are usually in the dance-pop mold—fast, frenetic and impossibly colorful—and often adopt sonic ingredients from genres thought to be tacky, such as the fluorescent synth lines of Eurodance or the chipmunk vocals of happy hardcore.

Among those early collaborators were Danny L Harle, who now produces for Caroline Polachek and Dua Lipa, and the mononymic producer Sophie, who Cook once said he admired for having "almost no regard for the walls between pop and experimental art." He describes this period as a time of intense creative inspiration. "We were spending all of our time making, thinking, talking about pop music, trying to crack the code in some way," he says.

The signature of PC Music, Cook explains, was never so much a specific group of sounds, but rather "an attitude of having music which is in dialogue with itself, in dialogue with both the mainstream and underground." The label eschewed conventional album cycles to pioneer a hyper-online release strategy, telling its story in fragments of DJ mixes, YouTube videos and janky, one-off websites. Their imagery embraced the glossy aesthetics of consumer and celebrity culture at its most vapid. One release, Cook and Sophie's "Hey QT," was themed around the idea of product placement for a fictional energy drink. It is a giddy firework of a club-pop anthem, at once wry and deeply felt, and one of the label's best.

Many, however, found their shtick off-putting. "All our friends thought what we were making was terrible," recalls Cook. "We were putting on empty club nights. Our friends thought what we were doing was—" he pauses, searching for the word, "trash, basically." He attributes this early resistance to the way PC Music was presented as a collective, which was playful and feminine at a time when London's electronic music scene skewed dark, masculine and self-serious.

(above) Cook wears a shirt by ACNE STUDIOS, trousers by ERL and shoes by PHILIPPE MODEL.
(opposite) He wears a shirt by EDWIN, trousers by ECKHAUS LATTA and shoes by PHILIPPE MODEL.
(previous) He wears a sweater by MARTINE ROSE.

(opposite) Cook wears a shirt by J.LINDEBERG, trousers by KILIAN KERNER and shoes by COMMON PROJECTS.
(below) He wears a sweater by MARTINE ROSE.

A particular sticking point for music critics was whether the project was sincere and not, as some felt, a bunch of art school hipsters trolling the industry with their flagrant disregard for good musical taste and penchant for online pranks. The press was also nonplussed, with one headline asking whether they were "the future of pop or contemptuous parody."

"I don't really care about things like authenticity in a strict sense when it comes to pop music," Cook argues, but you don't have to look too deeply to realize that his playfulness doesn't preclude a genuine love of the music. On Halloween in 2014, PC Music did a live stream on YouTube which included the liberal use of silly camera effects and ropey 3D graphics. During his set, Cook appears dressed all in black with ghoulish makeup, impossibly tall and thin. As he performs, he dances; his movements loose and wild, at once gangly and graceful. You can see how profoundly he is feeling the music. "It was so clear to us that it was genuine," he says.

The initial blowback didn't stop PC Music. In fact, Cook says, it galvanized him. They soon entered into a partnership with Columbia Records and established a family of regular collaborators including Charli XCX, Caroline Polachek, Carly Rae Jepsen and Sophie. "The most pivotal part of my musical development was finding these other people who are completely ride-or-die," says Cook.

PC Music's prescience was proven when the rest of the music world began trying to catch up to their way of thinking. Scroll through TikTok today and you'll hear super-fast, hyper-melodic music that sounds like PC Music did a decade ago. The warren of websites and Easter eggs they created for Reddit sleuths to decode is now a legitimate marketing technique employed by artists like Taylor Swift.[1] Their commentary on consumer culture and the collision of personality and brand no longer seems provocative in an age of influencers, where the term "sellout" has ceased to mean anything. And they have inspired a younger generation of artists who now make music under the genre banner of "hyperpop," a term about which Cook, like any good trailblazer, professes to feel ambivalent.

After PC Music's fringe ideas became part of the mainstream, the project started to lose its raison d'être. If it no longer sparked controversy, reasoned Cook, then what was it for? In 2023 he announced PC Music would close, choosing to end with a

" Our friends thought what we were doing was trash, basically."

(1) In 1976, game designer Warren Robinett hid what is thought to be the first Easter egg (so named for the hunt to find them) in a secret "room" of the video game "Adventure"—a screen that flashed "Created by Warren Robinett." It was an act of defiance against the game's publisher, Warner Communications, which Robinett knew was not going to credit him as the game's author.

deliberate punctuation mark rather than petering out or being sold off to a major label.

In the meantime, Cook has been stepping out from the shadows to become a pop star in his own right. For a long time, he had only a handful of singles under his own name. This changed dramatically in 2020, when he released *7G*, a seven-disc album containing 49 songs, which he followed just over a month later with another album, *Apple*. The latter is a tighter showcase of his production skills, while the former is more conceptual, with each of its discs centering a different instrument in his arsenal.

On the music Cook releases under his own name, he explicitly connects the dots between the realms of pure pop and experimental music—two worlds that have historically regarded each other with suspicion. There are two distinct sonic styles at work: songs that demonstrate his electronic wizardry, where a barrage of drums and chopped-up vocal samples can suddenly dissolve into the softest twinkling synths, and others more akin to bedroom pop with gentle acoustic guitar, where Cook brings his hesitant but tuneful singing voice to the fore.

Starting in 2016, Cook found himself spending more time in Los Angeles (what Cook calls "this bizarro pop music city") to work with Charli and Sophie, two other British transplants. "My flatmates took the piss out of me because I'd be spending very little time in London and still paying rent," he recalls. But the city held promise for him: Where London felt bogged down by history and cultural gatekeepers, LA was the opposite. "It's almost aggressively about the present here," he says. "It's: Oh, what's going on today? Who's in town this week?"

"And I love how open-ended it is; there really aren't any musical boundaries. Some synth weirdo might work on a massive Justin Bieber track." For some artists, Cook became one such synth weirdo. He was tapped to help produce the song "All Up in Your Mind" on Beyoncé's album *Renaissance*, though he describes the process as rather remote—he didn't attend any studio sessions and was simply given permission to tinker with some files. He didn't even know his contribution would be used in the final cut until a week before the album was released—then he was nominated for a Grammy for his work. When he produces for artists with whom he is more deeply involved, he seeks to respond to their particular creative visions. "When I'm working with Charli," he explains, "I'm not just playing beats and being like: "Okay, let's make a hit.' I'm trying to craft things that would inspire her or open a dialogue. I'm trying to really document that person and that moment in time."

During the pandemic, Cook locked down with his girlfriend of seven years, the musician Alaska Reid, in her hometown in rural Montana. He spent the year working on music in a small basement room and going out on hikes. "For someone like me, growing up in London, you're just not used to seeing that volume of landscape," he says, "it's just these huge mountains, the big sky." In that setting, he found himself particularly aware of his own Britishness. "I was the only person there with my sort of accent," he says, "which had this surreal, alien quality." This was the spark for his third album, *Britpop*, which took inspiration from Cook's sense of how Americans imagine Britain—a land of history, myth and fantasy. It was rolled out in May 2024 with a cover that references the Union Jack, lyrics evoking ancient pagan traditions and a name that jokingly refers to an era of British musical history in the 1990s. Yet, as is often the case with Cook, there's a deeper layer of irony behind the title: the fact that in 2024, we have never been further from a consensual understanding of either what pop music is or, in a post-Brexit world, what it means to be British.

When asked questions that veer toward emotional territory or biography, Cook becomes somewhat guarded. He steers away from those topics so politely and deftly that you might not even notice it happening. It's telling that his previously published interviews contain vanishingly little about his personal life. It might just be media savvy, or an understandable reluctance to express emotions in the public sphere, but even when he calls something "very moving," he says it in the even tone of a librarian.

There is one moment, however, where a different side starts to emerge: when conversation turns to Sophie, Cook's frequent collaborator, who died in a sudden, tragic accident in 2021. "The journey we had together was so specific and it had such a big impact on me," he says quietly. One song on *Britpop*, "Without," is dedicated to her. Cook also wrote a long text online that offers a beautifully detailed, thoughtful tribute to her artistry and personality. He mentions that references to Sophie pepper his work on *Brat*, on *Britpop*—everywhere. And while Sophie gained most acclaim during her lifetime for her striking ability to sculpt sound into dazzling new forms, he is keen to emphasize her poetic, lyrical imagination and authenticity; her understanding that we don't need to choose between the binaries of experimental and pop, human and machine, intellect and emotion, real and fake. "Things can be both," he says, at the very end of the interview.

(opposite) Cook wears a shirt by EDWIN and trousers by ECKHAUS LATTA.

(opposite) Cook wears a sweater by STOCKHOLM SURFBOARD CLUB, trousers by THEO and shoes by PHILIPPE MODEL.

Are millennials
ruining weddings?

ESSAY:
WEDDING CRASHERS

Words
ALLYSSIA ALLEYNE

At the turn of the millennium, think tanks posited that, with the normalization of child-rearing and cohabitation outside of wedlock, marriage would come to be seen as a lifestyle choice rather than a gateway to civic or religious participation. So perhaps it should come as no surprise that 25 years later, the wedding has become the ultimate personal branding opportunity, complete with hashtags, viral moments and limited-edition favors. Millennial couples, who now make up the majority of the marrying population, are firmly at the center of this trend.

Few wedding parties held today will stick to the traditional script. But while it costs nothing to jettison the father-daughter dance, write personalized vows and enlist a friend to officiate a secular ceremony, other customizations can be pricey. According to wedding-planning website The Knot, the average wedding cost in the United States topped $35,000 in 2023 (about 73 percent of the median annual wage).[1] While inflationary rises in venue fees and catering are responsible for much of the increased spending, there has never been a greater variety of nice-to-haves to tack on to the proceedings, from bespoke venue fragrances and Dutch Masters–inspired tablescapes to lavish pre-wedding parties and 5-foot-long cakes—markers of individual taste and self-expression, rather than familial union.[2]

Therein lies the paradox. "Weddings, especially ornate and expensive weddings, have become more prominent just as the social need for marriage is weakening," Julia Carter, a lecturer at the University of the West of England, and Simon Duncan, emeritus professor of comparative social policy at the University of Bradford, observed in a study on weddings and conformity in *The Sociological Review*. "Weddings have never been more free from cultural norms and official control, and are increasingly separate from the marriage itself which often becomes something of a sideshow."

It's easy to dismiss this apparent triumph of style over substance as a generational shift, another case of millennials ruining a vaunted institution. But in reality, this fusion of hyper-consumerism and look-at-me individuality has been building in the West for decades. Among the middle classes, weddings have been growing increasingly grand since the 1960s, with a major uptick around the early 1980s, likely buoyed by the widely broadcast wedding of Princess Diana and Prince Charles.[3]

" It's all about being visible and competing for the most visibility."

The ensuing decades saw the rise of the voluminous white dress, the three-day blowout, the Disney wedding and the elaborate floral display as couples (and vendors) progressively upped the ante and sought out an ever-increasing number of nontraditional venues. (The number of ceremonies hosted in religious institutions dropped from 41 percent to 22 percent between 2009 and 2017, with barns and banquet halls tying for top choice last year.) "Nowadays every aspect of a formal wedding has become so intensely merchandised

(1) It's not just the betrothed couple facing rising costs. The average cost to attend a wedding was $580 last year (up from $120 in 2021), factoring for travel, accommodation, gifts and attire.
(2) Scentscaping was described by *Brides* as *the* wedding trend of 2024. In addition to being the latest wedding must-have, however, advocates say that it can be an additional way to remember your special day, thanks to the strong link between smell and memory.

as to render its original design and purpose almost unrecognizable," social critic Caitlin Flanagan bemoaned in *The Atlantic* in 2001.

In this context, millennials can be seen to be simply iterating on a decades-long tradition of excess. But the question of why this generation chooses to reaffirm the tradition of the white wedding is more complex, especially given their apparent willingness to redefine the institution of marriage by marrying later, less often and on their own terms. (According to a Harris poll, 34 percent of engaged or married millennials have signed prenups, compared to just 5 percent of boomers.) Melanie Kennedy, a lecturer in media and communication at the University of Leicester and an editor of *The Wedding Spectacle Across Contemporary Media and Culture: Something Old, Something New*, ascribes this to the fact that millennials came of age just as grand weddings were ascending to a zenith of visibility.

" Even in economically unstable times, budgets for weddings are going up."

"I think celebrity culture in particular has a lot to answer for in giving us this sense that ordinary people like you and I can also have this big wedding," she says. "Whenever we see big media flash points going back decades—it might be a Hollywood star getting married, or it might be a queen or a princess getting married—these are moments that, through the sheer coverage that they get in the media, almost democratize that level of wedding, which filters down into trends that we see in things like wedding dresses and choices of cake."

(3) The "wedding of the century," the marriage of Princess Diana and Prince Charles, was watched by 750 million people around the world. Among other opulent expenses, the couple had 27 wedding cakes and Diana's dress cost $12,000 ($57,000 in today's money).

(4) Aspirational weddings did not start with social media and reality TV, however. Originally named *So You're Going to Be Married*, the magazine *Brides* has been offering brides-to-be counsel on what to buy for the big day since 1934. Founder Wells Drorbaugh, a former ad man, reportedly got the idea after reading an article on the "Depression-proof" wedding trade.

But it's not just celebrities promoting big weddings. The last 25 years have also seen the rise of wedding-themed reality TV (*Say Yes to the Dress*, a show about brides tearfully buying wedding dresses at a luxury Manhattan bridal shop, has run for 22 seasons and spawned nearly 30 spin-offs) and social media platforms, like Instagram and TikTok.[4] "Weddings are more photographed than they've ever been at any point in history because we all have cameras in our pockets," Kennedy says. "What you're seeing on your Instagram feed contributes to this shifting of the goal posts.... It's all about being visible and competing for the most visibility."

There's also the fact that, at a time when one in four Americans are religiously unaffiliated, weddings mean something different. Speaking to couples who had gone full white wedding,[5] Carter and Duncan found that the wedding, once an occasion to seek validation from families and communities, has now become a "celebration of the couple, and of their love and commitment, where the major value of the wedding is to confirm the couple's relationship."

The endurance of the wedding spectacle could also be viewed as a response to the times we live in. Among conservative couples, the veneration of the traditional wedding may be a way to hold onto institutions that "might otherwise weaken" as feminism and other social justice movements take hold, Kennedy suggests. "But equally, I'm not a complete cynic. I think some important, valuable elements of weddings remain very powerful at times when we really need them. There's a real decline in organized religion in the West. There are fears about war, there are concerns about the economy, there's political instability. But a wedding provides a space where there's a coming together of a community and family that is quite lost elsewhere in society."

She points to the fact that wedding costs have continued to rise despite an increase in the cost of living. "Another interesting paradox we see in the West is that even though we are in economically unstable times, budgets for weddings are going up. It shows again that at times of instability—whether economic, political, or cultural—we turn to marriage as a way of giving us stability and hope and optimism for the future: If we invest in this institution, then that's where we'll find that stability."

Of course, there's no moral or financial metric by which to measure the return on this form of investment. While most of the subjects of Carter and Duncan's interviews begrudged the "crazy," "excessive" or "horrendous" amounts they spent, they "simultaneously found justification in the importance of the event." Similarly, in a *USA Today* survey of 3,000 couples married between 2021 and 2024, 86 percent of respondents didn't regret the cost of their wedding. As ever, it seems, the value of a wedding, like a marriage, can only be determined by the couple at the heart of it.[6]

(5) Before Queen Victoria wore a white wedding dress to marry Prince Albert in 1840, brides would wear many different colors. A "white wedding" has since come to represent not just the custom of wearing a white dress, but formalized wedding traditions that include everything from the role of groomsmen and bridesmaids to the custom of the bride and groom cutting a tiered wedding cake.

(6) The value of a wedding might not be easily determined, but investing in the institution of marriage does seem to be paying dividends for millennials. Analysis of American Community Survey (ACS) data by Philip Cohen, a sociology professor at the University of Maryland, suggests that the falling divorce rate in the US is thanks to millennials making better marriage choices than previous generations.

HOME TOUR:

WORDS
ALI
MORRIS
PHOTOS
ALIXE
LAY

VILLA VENTORUM.

A ROMAN TRIUMPH IN MODERN BRITAIN.

In 1832, on a picturesque estate in Somerset, southwest England, a group of laborers came across something unexpected in the ground. In the absence of an archaeologist, they asked a local vicar, who was an amateur historian, to come and take a closer look. He was able to identify a number of Roman coins that dated to the reign of Emperor Constantius II in the 4th century, as well as what appeared to be the remains of a Roman villa—a find that would ultimately lead, after nearly two centuries of disjointed discovery, to its painstaking reconstruction.

Located within sight of the ruins of the original villa, Villa Ventorum is the result of an unprecedented collaboration between archaeologists and hoteliers. The reimagined Roman home opened in 2022 as part of a decade-long project to transform the estate of the 18th-century Hadspen House, after it was bought in 2013 by South African couple Koos Bekker, a telecoms billionaire, and Karen Roos, the former editor of *Elle Decoration South Africa*.

What began with the conversion of the estate's Georgian manor house into a hotel and spa quickly grew to include further accommodation, a retail store and various hospitality venues, all housed within restored agricultural outbuildings. Thirty acres of landscaped gardens have been tamed and hundreds of acres of woodland and farmland sustain an ecosystem that produces cheese, cider, meat and clean energy. A membership program offers a busy calendar of cultural and educational events led by in-house experts in entomology, biodiversity and regenerative farming. Renamed the Newt in Somerset—a tribute to the many

(below) Britain was part of the Roman Empire for over 350 years, from A.D. 43 to around 410. Before the Romans invaded, the islands of Britain had no single political or cultural identity; the Romans brought with them towns, roads, military garrisons and a centralized government. Much of this was abandoned when the Romans left Britain but the occupation has left a rich archaeological legacy that can still be discovered in the UK today, from villas and towns to forts and the magnificent Hadrian's Wall.

small amphibians that reside on the estate—it is now less a hospitality offering and more a visionary regional visitor attraction.

Given Bekker and Roos' vision—and seemingly bottomless pockets—it was perhaps inevitable that the Roman site would become part of the Newt's offering, but experts were surprised at the scale and ambition of the project. When teams of archaeologists began the process of unearthing the ruins in 2015, the dig became the largest privately funded excavation in Britain. "The world of archaeology is actually really small, and so I knew about this project from about week two," recalls Ric Weeks, who became the Newt's onsite archaeologist and exhibitions manager in 2021. "This kind of site is very common in Britain, but now it was being explored to a degree that hadn't happened before, and they had 18 months to do it, which is exceptional. In that time frame, you can really delve into the chronology and understand what's happening."

The excavations revealed that the villa had originally been built as a modest three-room farmhouse on the site of an Iron Age settlement. Between the 3rd and the 5th centuries it had been adapted and enlarged, probably as its owners' fortune grew, with the addition of a dining room and a more elaborate bathhouse, before it was abandoned in the early 5th century when the Romans left Britain. A brooch in the shape of a crossbow—according to Weeks, one of about seven in the world—was discovered in the final few days of the dig. It had been placed carefully in a box beneath the floor in one of the rooms, likely as an offering to the gods, and indicated that at the height of the villa's evolution, around A.D. 350, it was home to a noble who had a magisterial rank and was a substantial landowner. "The equivalent of a multimillionaire nowadays," Weeks says.

The brooch is now on display in a new glass-walled museum building alongside mosaics depicting Diana, the goddess of hunting, and Bacchus, the god of wine, and countless other artifacts found during the villa's excavation. The full-scale reconstruction is a short walk away along a path through a vineyard, and appears in the rolling green landscape as if in a Benouville painting. Realized in honey-colored Hadspen stone, topped with handmade terra-cotta tiles and wrapped by medicinal herb gardens, it follows the T-shaped plan of the original villa, approximately 180 feet wide and 70 feet long, with bedroom chambers, kitchens and a working complex of Roman baths all reconstructed using the same local materials and processes that the Romans would have used.

"After the 2016 excavations, the estate's owners and architect wondered whether we could attempt to reconstruct what we had evidence for in the ground," says Weeks. "Our partners at the Southwest Heritage Trust and many other experts came together to make an ambitious idea into a reality."

The villa is now open to the Newt's members for guided tours. There is always a risk of veering into theme-park territory with a project like this, but here this has been avoided thanks to the team's forensic attention to detail. Everything from the furniture to the food and drink on offer—doughballs with ricotta and poppy seeds, and conditum paradoxum, a sweet Roman wine made with

"Aspects of the villa's design echo how we aspire to live now."

(opposite) The double-height tablinum, or main reception room, includes vividly painted walls and a mosaic floor.

> "Decoration was used to show off status. Nobles were hugely snobbish."

saffron, white pepper and honey, for example—has been based on archaeological evidence. To demonstrate, Weeks picks up a pleasingly rotund glass from a desk in the villa's formal entranceway. "This looks like something you might buy in IKEA," he says, "but it's based on a tiny sliver of the rim of a glass that we excavated and sent to the British Museum, which then analyzed it against surviving glass in the Mediterranean. They found the exact style because it was made using a very standardized process." To recreate the design, the team contacted a glassmaker in Murano, Venice—the only facility in the world that could make the same glass to the same quality.

The villa's walls are made of wattle and daub and have been decorated with paintings featuring elegant borders, classical motifs, landscapes and portraits; the floors are rammed earth interspersed with intricate mosaics made by teams from Cambridge University using locally quarried stone—the same as those unearthed on the site. For the frescoes in the bathhouse's tepidarium and caldarium, a specialist team of conservators was brought in from Italy, who used a traditional, almost extinct, method known as Buon Fresco, which involves painting directly onto wet plaster. "Decoration was used to show off status," says Weeks. "Nobles were hugely snobbish, so they would make sure that the bathhouse—the part of the home you want to wow people with—would be where you concentrate your resources."

The villa's formal entrance, an arched doorway flanked by cast-bronze oil lamps, frames a view through the house and out into the garden. The symmetry and order prefigure the architecture of grand English country houses and gardens, and in many ways, aspects of the villa's design echo how we aspire to live now, with a focus on wellness and relaxation. There are easy connections between indoor and outdoor spaces, with its portico and landscaped garden,

(left)
The triclinium—a formal dining room where ancient Romans would recline at mealtimes.

while the bathhouse—the equivalent of a modern spa, complete with underfloor heating—would have been used two to three times daily.[1] The room used for receiving visitors of high rank, the tablinum, is perhaps the most ostentatious. Here guests would be wined and dined as they reclined on elegant couches and admired the decorative double-height ceiling and romantic wall paintings.

Some might be cynical about an archaeological project being so closely tied to a commercial venture and question its value and authenticity. Roman-inspired pottery and reference books are available to buy in the gift shop and, when the pinot noir vines planted around Villa Ventorum (using a single-stake trailing method favored by the Romans, of course) produce their first crop, the resulting wine will no doubt be packaged and sold to visitors. But the team recognize they are treading a fine line between the cultural and commercial, and are careful to strike a balance. It is, after all, precisely this unique model, where academia meets tourism, that enables this untold history to be brought to life in such an engaging way.

"One of the core goals at the start of this project was to explain more clearly and more openly why the Romans were here in Somerset," Weeks says. "In archaeology, we are taught to look at stones and try to link them to something bigger. But it's only when you actually raise a building up and make it real that it really hits you. I think that's the difference with this project: What we are offering here is a completely immersive experience."

(1) Roman bathing followed a specific process: Bathers would progress from an unheated room (frigidarium) to a warm room (tepidarium) and then to a hot room (caldarium) before heading back to an unheated room and taking a cold plunge.

FEATURES

NEW YEAR'S EVE.

GET READY TO STEP INTO THE FUTURE.

PHOTOS
CECILIE
JEGSEN
STYLING
CAROLINE
GUDMANDSEN

Set Design: Tine Daring. Hair: Mads Stig. Makeup: Sara Rostrup. Light Assistant: Michael Kehlet.

(above) Charlotte wears a dress by COPERNI and earrings by AMALIE GRAUENGAARD.
(opposite) Charlotte wears an outfit by STINE GOYA. Curtains by &DRAPE.
(previous) Phat wears a jacket by STINE GOYA and a vintage dress by IVAN GRUNDAHL from STRAND32.

(below) Charlotte wears bracelets and a bra by AGMES, a jacket by NICKLAS SKOVGAARD, jeans by ACNE STUDIOS and vintage shoes by
 GUCCI from STRAND32. Rug by MASSIMO COPENHAGEN.
(opposite) Phat wears a top by MFPEN and sunglasses by FLATLIST.

(below) Charlotte wears a jacket by ACNE STUDIOS, a bra by AGMES, a skirt by ALECTRA ROTHSCHILD / MASCULINA and earcuffs by FREYA DALSJØ.
(opposite) Phat wears a jacket by STINE GOYA, a vintage dress by IVAN GRUNDAHL from STRAND32, trousers by MFPEN and shoes by COS.

PHOTOS AARON TILLEY
SET DESIGN SANDY SUFFIELD

88

FEATURES

ZODIAC.

AN ELEMENTAL STUDY OF ASTROL-OGY.

(above) All aflame—The fire signs, represented by a rosette (ARIES; ambitious), a glass of champagne (LEO; decadent) and a compass (SAGITTARIUS; curious).
(previous) Making a splash—The water signs, represented by a key (CANCER; homebody), chess pieces (SCORPIO; tactical) and dice (PISCES; spontaneous).

(above) Down to earth—The earth signs, represented by a De Ville Prestige OMEGA watch (TAURUS; reliable), opera glasses (VIRGO; attention to detail) and an epic book (CAPRICORN; patient).

The concept of triplicity—where the 12 zodiac signs are organized into four groups based on the classical elements (earth, water, air, fire)—was popularized by the Roman poet and astrologer Marcus Manilius in the *Astronomica* (A.D. 30–40). The elements are considered an important "essential dignity"—which astrologers use both to understand the relative influence different planets will have on someone's life and which signs will be more compatible with one another.

Though considered a pseudoscience since the 18th century, astrology—and in some forms, triplicity—has been part of cultures around the world for 3,500 years and its legacy is evident in everything from great works of literature and music to the actions of President Ronald Reagan. According to his chief of staff, Donald Regan, after the assassination attempt on Reagan, "virtually every major move and decision… was cleared in advance with a woman… who drew up horoscopes."

(above) Sky high—The air signs, represented by two glass mugs (GEMINI; duality), a balancing spoon (LIBRA; equilibrium) and spilt milk (AQUARIUS; rebellious).

THE ARCHITECT-TURNED-MURAL PAINTER PLAYING WITH SPACE.

AT WORK WITH: ELVIRA SOLANA

WORDS EMILY NATHAN
PHOTOS MARINA DENISOVA

The work of ancient muralists was nomadic in nature. In order to paint enduring scenes of daily life, history or mythology on the walls of temples, tombs and public buildings, they were required to continually displace themselves, adjusting and adapting their work to suit each site and patron. A shifting physical context was their only constant.

In keeping with this tradition, incessant movement has shaped the professional life of Spanish-born artist Elvira Solana. Though she earned a degree in architecture in 2012, she doesn't design new buildings. Solana has instead spent the last six years decorating the interiors of existing ones, painting illusory perspectives, landscapes and even architecture. And in the manner of her predecessors, she has traveled for each commission—working on-site in private homes, hotels and boutiques in Paris, Provence, Lisbon, Milan and Santo Domingo before moving on, every few months, to confront the specifics of the next new space.

"When I left school, the economy had paralyzed the architecture industry and I got tired of being treated like a child with nothing to offer," Solana says, speaking from her home in a small fishing town on Spain's northern coast. "I missed the feeling of working with my hands. So I quit and decided to start painting, but I guess I couldn't get rid of the architect in my core. You might say it's only natural that I ended up painting on the wall."

> " It's only natural that I ended up painting on the wall."

Solana's lush, lyrical murals stretch from floor to ceiling, extending across windowsills and doorframes and occasionally taking over entire rooms. Often her compositions appear to break through the wall, opening onto expansive trompe l'oeil views of an imagined world, at turns tropical, cosmopolitan and pastoral.[1] Others are more purely geometric, but all share a searching, gestural touch that explores the nuances of darkness and light, form and absence.

She approaches each new space with an investigative curiosity. Before Solana paints a single stroke, she spends time watching: noting the room's architectural features, the flow of natural light as the sun moves through the sky and the play of shadows across the wall. She then weaves this understanding of the physical site into a design that draws on a history of mural painting dating back through the Renaissance to Roman frescoes, incorporating references from a visual lexicon that includes ancient mythology, historical anecdote and contemporary culture.[2] It is only then, having developed a series of preparatory sketches and studies, that she begins to paint, building up

(above)　　　The bathroom in Solana's home features a Grecian-style frieze and a trompe l'oeil shelf with geometric forms that play with the architecture of the space.

"I decided to start painting, but I guess I couldn't get rid of the architect in my core."

the image gradually to achieve complexity and depth.

"People often ask me to pick one: Am I an artist or an architect?" she says. "But I can't answer. I have always interpreted murals from an architect's perspective, and I believe that a sensory perception of shapes can create and define a room as much as its walls, roof or pillars. So I use paint to construct a new space; instead of knocking down a wall, I change the way we perceive the wall. In a way, I am building architecture by painting architecture."

Early in her career, Solana transformed her home into a laboratory of overlapping perspectives and spatial planes. In her living room, one wall appears to alternate between interior and exterior fields: Nooks and cracked-open doors lead the eye through a maze of rooms, suggesting deeper, unseen spaces; illusory windows frame a sequence of marbled colonnades and a tranquil sea.

In her bathroom, she decided to attempt a more specific illusion: inverting the angle of the corners with paintings of three-dimensional geometric forms placed on a trompe l'oeil shelf that runs around the room. Below this is a tongue-in-cheek frieze titled *Private Pleasures and Misfortunes*—a strip of Grecian-style fresco whose allegorical figures perform a suite of erotic activities. Visitors will likely find pleasure in the overall result, Solana explains, but she reserves a private satisfaction for the unassuming painted structures in the corners.

Such experiments with space recur throughout Solana's murals. In another early work, she painted a hunt under moonlight: nude bodies thrusting and pressing against each other beneath bowing trees and stone arches. The work is rich and figural; it's a complex composition that appears narrative in scope. Yet, as she explains, this was incidental—her goal was to explore fluid, painted transitions, investigating how to elide a human body into an animal, and an animal into architecture. The image's visual appeal operated as a kind of Trojan horse for experimentation with color and form—and a way to ensure its longevity.

"Vitruvius taught us that beauty was one of the three founding pillars of architecture, and you really can't discount it: You can't forget the eyes," she says.[3] "From my education, I understand the logical part of the visual puzzle; I know structure and composition. It's when the beauty of the surface comes into play that I'm in new territory, and here I let myself indulge in the pure pleasure of painting. I believe that beautiful things have a better chance of survival."

During her initial research into mural painting, Solana was thrilled to discover that her decision to straddle architecture and painting has a long historical precedent. Those ancient muralists were often also trained as architects, with their work similarly bringing walls, windows and doors into harmony with flat representation. The embrace of linear perspective by muralists during the Renaissance further vindicated Solana's understanding of the fluid relationship between two and three dimensions.

Yet her impulse to address architectural questions of space through painterly methods is as much a principled undertaking as a theoretical one. She occasionally describes her murals as "surface interventions," implying interruption, and she insists that murals are a way to give anyone an inspiring vista, even if they can't afford an actual ocean view.

"There are physical and material limits—I believe and respect that—but they won't stop me," Solana explains. "Of course, we can't all have a swimming pool, but in a virtual way, I can help people expand their home. And with paint, I build on something that already exists, and that is a much more sustainable way to conceive of the future of our spaces."

For now, Solana is busy establishing her first brick-and-mortar studio in Madrid. Its defining feature is ample wall space. Always keen to draw a connection with history, she explains that more recent muralists have put down roots and worked this way, too, painting on massive swaths of canvas from the comfort of their own atelier. Her goal is to continue making "refurbishments" in houses, as architects do, but by painting the wall rather than knocking it down. She also hopes to one day work with clients from the beginning of a project, designing their home, and its murals, from the ground up.

"As a muralist, you're painting the background to someone's life," Solana says. "It should be the context, not the main character; good architecture—and good painting—should be invisible. It simply facilitates the life that's lived there."

(1) Translating to "deceive the eye," the French term *trompe l'oeil* describes a technique that creates the optical illusion of three-dimensionality on a flat surface, making painted objects appear real through the use of perspective and shading.
(2) Much of what we know about ancient wall painting comes from the Roman cities of Pompeii and Herculaneum, which were buried in volcanic ash when Vesuvius erupted in A.D. 79. There, excavations have discovered murals that include trompe l'oeil marble, still lifes, narrative friezes and illusory architecture.
(3) Vitruvius was a Roman architect and engineer best known for *De Architectura* (On Architecture), a 10-book treatise in which he outlined the principles of good architecture, emphasizing the importance of durability, functionality and beauty.

MATTY

WORDS ELLE HUNT
PHOTOS TED BELTON
STYLING NADIA PIZZIMENTI

YES, CHEF!
THE
MULTIHYPHENATE
CULINARY
FORCE ON
HAVING A
FINGER
IN EVERY PIE.

MATHESON

A chef's toque is only one of many hats worn by Matty Matheson. The Canadian restaurateur presently has five businesses to his name—Matty's Patty's Burger Club, Prime Seafood Palace, Rizzo's House of Parm, Maker Pizza and Cà Phê Rang—and a sixth is on the way. Formerly a regular on videos for Vice, he now has 1.5 million subscribers to his own YouTube channel and his third cookbook, *Soups, Salads, Sandwiches*, was published in October. Then there's Blue Goose Farm in Ontario, which supplies his restaurants, a collection of kitchen utensils, Matheson Cookware, and his line of pantry staples.

Most likely, though, you'll know Matheson as Neil Fak, the handyman with a heart of gold on FX's award-winning comedy-drama series *The Bear*. Matheson is also an executive producer of the show and a culinary consultant, working alongside Courtney Storer (the sister of series creator Christopher Storer) to ensure that its depiction of hospitality rings true to life. Whether it's making restaurants, or making television, as Matheson explains: "I love making things happen."

ELLE HUNT: You have so many different roles—how do you describe what you do?

MATTY MATHESON: Even early on, people would say, "Are you a chef? Are you this, are you that?" I'm always just like, "Canadian legend." Maybe because I grew up around punk and hardcore, I think labels are pretty stupid. I'm just me. I'm able to create in a lot of different spaces.

EH: Do you distinguish between the creative work you do with *The Bear*, for example, and in the kitchen?

MM: They all lend themselves to having different types of perspectives. The way I think about restaurants, or about acting, or anything, is that it has to come from a particular place. I think if you don't know *why*, then you will never know *how*. All of my restaurants are based on very firm memories or ideas. Matty's Patty's started from these pop-ups where we would just give cheeseburgers away. Cà Phê Rang came from my love of Vietnamese food. With Prime Seafood Palace, we really got to step into the world of architecture and design, which I've always loved. Acting and working on *The Bear* is a whole other thing: All my businesses come from me; *The Bear* comes from Chris [Storer, showrunner]. I'm just a part of that, helping get him to the place where he wants to get to, on the producing side.

EH: *The Bear* paints a fairly brutal picture of the service industry. What was your experience of getting started?

MM: I worked at Le Sélect Bistro in Toronto, an iconic restaurant that's been around for over 40 years. It was a really amazing time: People were being chefs to be chefs, like a real trade. Now, because of the internet, celebrity and everything else, I think people want to become chefs to become content creators. I'm really happy that I was able to have a career pre-internet, with the good and the bad. Like, was there HR in the early 2000s?... I worked with some pretty wild chefs. There was a certain level that you were expected to be at, and you needed to rise to that occasion. It was tough, but I look back on it fondly.

(opposite) Matty wears a vintage suit and a brooch by CAROLE TANENBAUM VINTAGE COLLECTION.
(previous) Matty wears a vintage suit and a shirt by NEIL ALLYN.

EH: What are the skills you learned in that time that you carry with you today?

MM: I love teams. I'm a big fan of working beside someone else, of having a goal and everyone moving towards that. I love cooking French food, even though I don't have a French restaurant—maybe one day. And I learned a lot about people. I came from a small town and back in the day I was working with actors, jazz singers, artists…. The industry is so eclectic—everyone comes from a different walk of life. That was a really cool thing: Being 22 and hanging out with a 40-year-old, being around a lot of different life experiences.

EH: What led you to step in front of the camera?

MM: This was back when "content" wasn't a thing. There was no space for somebody like me before: Either you were a chef or you were on Food Network. I just made a cheeseburger video. I'd never done it before and I thought: Why not? I think the thing that resonated very quickly was that I was able to be myself in front of a camera. I wasn't that celebrity, network-style chef; I was just me, cooking like how I cook at home. That opened a lot of doors. My friends were doing things at Vice, and they were like: "Yo! We're doing some food shit now." Honestly, it was as easy as that; I wasn't out there trying to pitch.

EH: What's a food trend you think is overplayed?

MM: I don't understand trends, or TikTok or Instagram. If you're chasing, you're not building. There might be some goat's-cheese strawberry strudel friggin' salad going on right now—I honestly don't know—but let's focus on seasoning our salad: The right ratio of oil and vinegar and salt, freshly cracked black pepper, making it perfect. Everyone thinks that they need to be content creators, like "How does it look on Instagram?" but that isn't it. Making delicious food, and making it as simple and uncomplicated as possible, will always win.

EH: This brings to mind your new cookbook, *Soups, Salads, Sandwiches*.

MM: This book is an easy win for everybody. Everyone has "their salad," or "their pasta"—I make mine all the time—but you always get stuck with it. This book is truly fun and easy: Flip a page, pick a fucking sandwich. It's very simple. Even the publishers were like: "That's the title?!" But a title for a cookbook doesn't need to be a sentence. It's a bunch of recipes for soups, salads and sandwiches. That's what it is. There's no tricks.

EH: So what turns a good sandwich into a great sandwich?

MM: I'd say the texture when you bite into it, being aware of that. If you're having crunchy, crispy, toasty bread, you would want something soft inside. If you have a softer outer, you'd want a harder inner—something that creates a little resistance. I'm a big fan of mouthfeel. With something as simple as a white-bread sandwich with just slices of ham and cheese, if you add a pickle or onion for that little crunch, all of a sudden, that's a really nice sandwich.

EH: What makes a good restaurant? What attributes do you prioritize in your own?

MM: A genuinely warm welcome; nice music. I used to play really loud music in my restaurants, but I'm older now. I don't want to think too much when I'm in a space; I want to feel relaxed. Comfortable chairs are nice; simple rooms, simple lighting. I'm a "less is more" type of person. Table maintenance is big for me: If you can just strike something from a table every time you go, or give it a wipe in a gentle, nonchalant way—it goes a long way.

> "Maybe because I grew up around punk and hardcore, but I think labels are pretty stupid."

(above) Matty wears a vintage suit, a shirt by NEIL ALLYN from ANDREW'S FORMALS, shoes by OFFICINE CREATIVE and a brooch by CAROLE TANENBAUM VINTAGE COLLECTION.

EH: What did your work on *The Bear* involve?

MM: I worked with the writers, costume team, designers—everybody—to build out the restaurant, the aesthetics, the way people move through it. How do people speak in the kitchen? How are they articulating a menu? It's just the attention to detail: When we're creating this world, everything matters, especially now that everybody's watching. We need to care about what the walk-in [fridge] looks like, for example. I remember going in, on the first season, and the walk-in had all this food in it. I was like: "You guys need to get rid of all of this: They wouldn't have boxes of carrots, they'd have *a* box of carrots because they couldn't afford anything more." Everyone's so used to making television, everything's very full and art-directed. When I first got there, I was just taking away pots and pans and spoons, because these guys [on *The Bear*] have only what they need.

> "There was no space for somebody like me before: Either you were a chef or you were on Food Network."

EH: As well as building the world behind the scenes, and producing, you're in front of the camera. How do you juggle those two roles?

MM: It's a lot. Acting is the hardest thing I do. Everything else is so easy compared to that, honestly. These actors are so good, and I'm like "Uhhh…." There's no chill zone. I need to say my shit at the right time so that they can say their shit. It's like doing service: When it's go-time, you need to show up for your team. You need to know your shit, and you need to be prepared. It's very intense.

EH: What's your next restaurant venture?

MM: I'm about to open a new restaurant: a seafood diner, inspired by my love of the Maritimes, growing up out there and eating lobster bisque, clam chowder and oysters.[1] My grandfather had a diner for 20 years and I can still taste his food perfectly. I think this restaurant is truly going to be a love letter to ol' Grampy Matheson. In the future, I'd love to have a crazy omakase spot. But I'm happy where I'm at.

EH: This is the Party issue of *Kinfolk*. What's your approach to hosting?

MM: I just want everyone to be taken care of. Always having enough food, always having enough drinks: It can be that simple. I don't like it when people feel like they can only have one of something—when you go to somebody's house and there's a cheese plate with like, three crackers. I'm an abundance guy. Get it to a place where nobody feels awkward. You want to be able to go up and fill your plate, and then have more.

(1) The Maritimes is a region of eastern Canada consisting of the provinces of New Brunswick, Nova Scotia and Prince Edward Island, where Matheson's family have roots dating back to the 18th century.

PARTY.

CONTENTS

114 — 133	Small Gatherings
134 — 151	Weddings
152 — 169	Soirees
170 — 176	Holidays

Small Gatherings
Drinks and dishes to bring people together.

Weddings
Flowers, decorations and a cake you can make.

Soirees
Simple tips for evening entertaining.

Holidays
New ways to connect during the festive season.

For a full list of credits, please see page 176

1.
SMALL GA

THERINGS.

WHIPPED BUTTER FROM ATELIER SEPTEMBER

SERVES 4

1 cup (250g) unsalted butter, at room temperature
¼ cup (50ml) buttermilk
½ teaspoon (2.5g) salt

Use a stand mixer fitted with the paddle attachment or use a hand mixer to whip the butter for about 10 minutes, until it is light and foamy. Add the buttermilk and salt and keep whipping. The texture should be like heavy whipped cream or lighter—it might take another 5 minutes. Keep at room temperature until serving.

Adapted from *Atelier September— A Place for Daytime Cooking*, published by Apartamento.

SMALL GATHERINGS

The Starter: Whipped Butter —on Everything

Q&A: Frederik Bille Brahe

ABOUT:
Frederik Bille Brahe is a Danish chef, restaurateur and the creative mind behind some of the most popular cafés and restaurants in Copenhagen—Atelier September, Apollo Bar and Kafeteria.

The whipped butter mound at Atelier September is something of an icon in Copenhagen's food scene. How did it come about?

I needed to make butter interesting for me to work with as it's difficult to avoid when you have a restaurant. I learned from the best that whipping butter with buttermilk gives it depth and acidity, as well as a beautiful fluffy texture. Suddenly, butter became something I could play with.

What do you add it to?

The flavor is everything. Our whipped butter started at Apollo Bar and was later added to a variety of dishes at Atelier September—not only as companion for sourdough bread but also served on porridge and used for frying omelets. Whipping butter creates a beautiful fluffy texture.

Do you have any serving suggestions?

It needs to be room temperature. You could use huge amounts to shape something fun and beautiful, like a cloud of butter. I personally love to scrape some onto the edge of a plate or into a scallop shell. It's very dreamy.

SERVING SUGGESTION: In France, buttered radishes are a classic snack: Trim the leaves and stems off a bunch of radishes and cut them all in half. Arrange the radishes cut-side up, spread whipped butter on each half and finish with a pinch of flaky sea salt.

SMALL GATHERINGS

The Menu: People Are Coming Over

Recipes by Easy Peacy.

ABOUT:
Easy Peacy is a Copenhagen–based catering company founded by Stine Kirkegaard and Ida Ravn that takes inspiration from the Italian way of sharing meals—big plates of food in the middle of the table for everyone to enjoy.

Shallot Tart with Anchovies and Olives

SERVES 12

Canola oil (or similar)
15 to 20 shallots, depending on size, thinly sliced
½ cup (120ml) balsamic vinegar
8 cloves garlic, thinly sliced
4 bay leaves
Salt and pepper
2 sheets puff pastry
2 eggs, beaten
1⅔ cups (400g) crème fraîche (use 50% fat if available)
Grated zest of 3 lemons
15 to 20 anchovy fillets
About 30 pitted black olives
Fresh oregano or sage

In a large pan over low heat, warm a splash of oil, add the shallots and stir. Once slightly browned, add the balsamic vinegar, garlic and bay leaves. Season well with salt and pepper and cook for about 30 minutes. Remove and discard the bay leaves and leave the compote to cool.

Preheat an oven to 425°F (220°C). Roll out the puff pastry on a baking sheet lined with parchment paper and spread the onion compote over it evenly, leaving a 1-inch (2 to 3 cm) border. Score a pattern into the border before brushing with beaten egg and bake the tart until the pastry is golden and crisp, about 15 to 20 minutes.

Meanwhile, whip the crème fraîche with an electric mixer until stiff, add lemon zest and salt and pepper to taste, and whip again until the same consistency.

Take the tart out of the oven (if making in advance, reheat in the oven at 400°F [200°C] for 5 to 10 minutes) and decorate with the anchovies, olives and herbs. Serve with the whipped crème fraîche, good bread with salted butter, and an endive salad with mustard vinaigrette.

121

Q&A: STINE KIRKEGAARD, Easy Peacy

Who was the last person you had over for dinner? My in-laws—I made white fish with a green sauce made from lemongrass, cilantro, vinegar and olive oil, served with roasted potatoes and green salad.

What advice would you give someone hosting a dinner party? Always, always prepare in advance. All chefs know how little should be prepared à la minute. Invest in good resealable containers and get everything done the day before, including picking herbs.

What can you do if you have a last-minute guest? I tend to make too much food because I'm always anxious about making too little. But it's also a great way of being prepared for an unexpected guest, as you can easily make the portions a little smaller, so it goes round more people. It's also why you should always serve good quality bread and butter to your guests. Otherwise, the host just has to go without!

Should you ask guests to bring food or wine? I would say it depends on the party. If you're hosting your friends or family, you can ask them for anything—food or wine. We don't really host fancy dinners but if you were, I don't think it would be okay to ask guests to bring anything. Personally, I would never ask guests to bring starters or a main because of the risk that they bring the wrong thing, but I never have a problem with them bringing dessert.

Chicken with Langoustine Sauce and Chives

SERVES 12

FOR THE CHICKEN:
12 chicken drumsticks and/or thighs
 (organic, if available)
Salt and pepper
Canola oil (or similar)
3½ tablespoons (50g) unsalted butter
1 whole head of garlic
A handful of fresh herbs, such as thyme
 and rosemary

FOR THE SAUCE:
Canola oil (or similar)
2 pounds (1kg) langoustine (or lobster)
 shells (preferably saved from Langoustine
 Toast on p.161)
⅔ cup (150g) tomato paste
1⅔ cups (400ml) white wine
2 tablespoons pickled peppercorns
4 sprigs tarragon
5 cups (1.2L) heavy cream
10½ tablespoons (150g) cold salted butter
½ bunch chives, finely chopped
Salt and pepper

For the chicken, preheat the oven to 325°F (165°C). Season the chicken with salt and pepper. In a large pan, heat the oil with the butter over medium-high heat. In batches, brown the chicken along with the whole garlic head and the fresh herbs for five to ten minutes, until the chicken skin turns golden brown.

Transfer the chicken to a baking dish, pour the cooked oil, garlic and herbs over the chicken, and cover with aluminum foil. Roast until the juices run clear when you insert a skewer into the thickest part of the chicken—about 30 to 40 minutes. Rest on one side and discard the garlic and herbs.

For the sauce, in a large pot, heat the canola oil over medium-high heat. Add the langoustine shells and lightly brown. Add the tomato paste and stir well. Add the white wine and let it reduce to about a quarter of its volume before adding the pickled peppercorns, tarragon and cream, and simmer over low heat for about 20 minutes.

Strain the sauce, discarding the solids, and reduce further in a small pot over low heat for about 5 minutes. Cut the cold butter into cubes and whisk it into the sauce, add about two-thirds of the chives and season with salt and pepper.

To assemble, place the chicken on a large platter, pour over the sauce and garnish with the remaining chopped chives. Serve with steamed baby potatoes and a salad.

Mushroom Ragù with Tagliatelle and Parmesan

SERVES 12

4 eggplants
7 ounces (200g) dried mushrooms
1 cup (250g) walnuts
Extra-virgin olive oil
3 yellow onions, finely chopped
8 garlic cloves, finely chopped
5 carrots, finely chopped
5 celery stalks, finely chopped
4 sprigs rosemary
8 bay leaves
2 pounds (1kg) fresh mushrooms
1¼ cups (260g) tomato paste
3 14.5-ounce (400g) cans peeled tomatoes (preferably canned cherry tomatoes)
Salt and pepper
2 cups (500ml) red wine
2½ pounds (1.2kg) tagliatelle or similar pasta
Parmesan cheese, for serving

For best results, prepare the ragù the day before. Preheat an oven to 300°F (150°C). Wash the eggplants and poke small holes in them with a fork. Place in a baking dish and roast for at least 30 minutes or until well done.

Immerse the dried mushrooms in just enough water to cover, and toast the walnuts in a dry pan until lightly browned. Set both to one side.

Heat a large heavy-bottomed pot over medium heat and add enough olive oil to cover the bottom. When the oil is hot, add the chopped onions, garlic, carrots and celery. Stir in the rosemary sprigs and bay leaves.

Chop the fresh mushrooms into roughly ½-inch pieces.

Once the vegetables have softened, increase the heat and add the fresh mushrooms. Cook until the water they release has evaporated. Squeeze the soaked mushrooms over the water they were soaking in, set the soaking water to one side, add the mushrooms to the pot and cook until the water evaporates. Mix in the tomato paste and let it cook for a few minutes, stirring frequently. Add the canned tomatoes, 2 to 3 teaspoons of salt and plenty of pepper, and mix well, reducing the heat to low.

In a blender, grind the toasted walnuts into a fine powder and add to the pot with the roasted eggplant, having removed the skins and torn into pieces. Stir before adding the red wine and the reserved mushroom-soaking water. Mix everything well, cover the pot and let it simmer over low heat for at least 1 hour, stirring occasionally. Remove and discard the bay leaves and rosemary stems. Transfer the ragù to a resealable container, allow to cool and store in the refrigerator until needed.

In a large pot over medium heat, reheat the ragù, stirring occasionally. Meanwhile, bring a large pot of well-salted water to a boil, add the pasta and cook until al dente, according to the package directions. Set aside 1 to 2 cups of pasta water and drain the rest.

In a large bowl, mix the hot ragù with the pasta and some of the reserved pasta water, adding a little at a time to reach the desired consistency. Serve on a large platter and grate plenty of Parmesan over the top. Finish with salt and pepper to taste.

ADVICE
ON PLATING:
ANNA JONES,
@we_are_food

Before I started writing my own cookbooks, I spent years working as a food and props stylist for other chefs and cooks, including Jamie Oliver and Anna del Conte, so I've spent a lot of time thinking about how food looks good on a plate. To me, plating is the final part of the story; we eat with our eyes. When I have people over, I make a bit more effort to put my food on the plate with care and attention. Here are a few simple tips:

• Amazing produce is always going to shine, so shop well and buy the best and most beautiful ingredients your budget will allow.

• I always try to keep a little of whatever herbs have gone into the dish to use as a garnish— you add color and tell a story of what's in the dish before your guests even take a bite.

• I love to bring food to the table for sharing. That way, I only have to make one beautiful plate and it feels much more relaxed. Thrift stores are great places to pick up the kind of big bowls and platters that will give your food space and make it look more generous.

• If something looks lackluster, then delicate herbs, edible flowers or springy salad leaves are your friends, as they add lightness and interest. Otherwise, a little drizzle of good olive oil can create a pretty pattern and add a buttery, rounded flavor.

Radicchio Salad with Black Currant–Raisin Vinaigrette, Horseradish Cream Cheese and Hazelnuts

SERVES 12

4 heads of radicchio
8 ounces (250 g) fresh cheese (such as good cream cheese or fresh goat cheese)
2 inches (5 cm) fresh horseradish, peeled and finely grated
Grated zest of 2 lemons
1 cup (250 ml) extra-virgin olive oil
Salt and pepper
1¼ cups (250 g) thawed frozen black currants (or other dark fruits like blackberries or cherries)
2 tablespoons sugar
¾ cup (150g) raisins
2 teaspoons balsamic vinegar
Canola oil (or similar)
2 to 3 handfuls of hazelnuts

Separate the radicchio leaves, and wash and dry thoroughly. In a medium bowl, mix the fresh cheese with the horseradish, lemon zest and ¼ cup (50 ml) of the olive oil. Season with salt and pepper and refrigerate until needed.

In a small saucepan, combine the black currants and sugar. Bring to a simmer, then reduce the heat. Add the remaining ¾ cup (200 ml) of olive oil and stir until well combined. Stir in the raisins, and season with balsamic vinegar and salt and pepper to taste, balancing the sweet and salty flavors. Simmer over low heat for a few minutes before transferring the vinaigrette to a container and leaving it to cool.

In a small pan, heat a splash of the canola oil over medium heat. Add the hazelnuts and toast until golden brown. Sprinkle with salt and set aside.

To assemble, arrange the radicchio leaves on a large platter and dollop with the horseradish cream cheese. Drizzle over the black currant–raisin vinaigrette. Finish with toasted hazelnuts, salt and pepper.

ABOUT
Benoît d'Onofrio, known as Le Sobrelier, is a French sommelier who has turned his attention to creating complex and nuanced nonalcoholic drinks at restaurants like Dame Jane—a neighborhood spot in Paris.

SMALL GATHERINGS

The Beverage: Thoughtful Drinks for Nondrinkers

Recipes by Le Sobrelier.

Tangerine Dream

MAKES 10
3½-OUNCE DRINKS

15 tangerines
2 ears of corn, shucked
1½ cups (160g) instant oats
3 teaspoons honey
1½ ounces orange blossom water
½ fresh medium-hot chili pepper

Peel the tangerines (reserving the peels), place in a large bowl and mash to extract the juice. Strain the juice through a fine sieve into a jar and reserve the solids.

Fill a large pot with 10 cups (2½ liters) of water, bring to a boil and add the corn. Cook for 15 minutes, then remove the corn (without draining the water) and set in a bowl of ice water for 5 minutes.

Using a knife, strip the kernels from the corncobs into a large bowl and reserve. Add the stripped corncobs and the reserved tangerine solids and peels to the pot of water and cook over low heat for 45 minutes, stirring occasionally. Strain the broth through a fine sieve into a large bowl, discarding the solids. Preheat the oven to 325°F (165°C). Place the oats on a baking sheet and toast for 20 minutes, stirring around halfway through.

In a blender, combine one-third of the corn kernels, one-third of the toasted oats and one-third of the corn/tangerine broth with 1 teaspoon of honey. Blend until smooth and pour into a large bowl. Repeat twice with the remaining corn kernels, toasted oats, broth and honey.

Strain the blended mixture through a fine sieve into another large bowl, add the reserved tangerine juice and the orange blossom water and stir until combined. Pour into a jar, add the chili pepper half, cover with a clean cloth and leave at room temperature for 24 hours.

Remove the chili pepper and store in the refrigerator for up to three days. Serve cold.

WHAT WOULD YOU MAKE IF WE WERE COMING OVER FOR DINNER TONIGHT?

Duck Fattee—a Lebanese dish to impress! Layers of jeweled rice with saffron, pistachios and raisins, cinnamon roast duck, crisp bread, a scented duck broth to make the rice moist, and crispy onions, yogurt, parsley and pomegranates to finish. It is delicious, looks impressive and is easy to make.
SAM CLARK
@restaurantmoro

When I host dinners, I like to keep it super simple; family-style dining. One of the best things is to have snacks on the go—a good pâté or parfait with a lovely bit of warm bread and butter. I always make sure I've got either a good bottle of champagne or a cold white wine, or if I'm making cocktails, that I have it all set up and ready to go. Making it so you can host easily and be there for your guests—that's the main thing.
THOMAS STRAKER,
@thomas_straker

We would start with some melon, figs, very thin slices of different kinds of cheeses and raw ham. Then I would make a tomato galette with a salad with a lot of herbs, and we'll end with a buttermilk ice cream, topped with a vibrant, green fig leaf oil, so we can have a last taste of summer.
ANDREA SHAM
@andrea.sham

Whatever looked good at the farmer's market. Right now, it would be a glut of tomatoes. We celebrate tomatoes in this house with what I would call an appropriate level of obsession. Perhaps start with a Sungold and Magic Bullet Tomato salad with a dressing inspired by Jeow Som—a Lao dressing based on fish sauce, lime juice and sugar with other aromatics and herbs.
JON KUNG
@jonkung

Tipple Tapple

MAKES 1 DRINK

3 ounces fresh apple juice
1½ ounces olive brine
1½ ounces filter coffee or the value of a full ristretto
Ice
2 ounces tonic water

Combine the apple juice, olive brine and coffee in an ice-filled shaker. Cover and shake vigorously, strain into a tumbler with ice and top up with tonic.

"Don't be afraid to ask your friends to help. Put someone in charge of filling glasses, ask for help in the kitchen if you need it, and get friends to pick up anything you are missing on the way. It's all part of it—you don't need to do it all!"
ANNA JONES
@we_are_food

Strawberry Surprise

MAKES 10 3½-OUNCE DRINKS

1½ cups (300g) white rice
1¼ pounds (550g) strawberries
1 bunch sage
6 tablespoons (90ml) rice vinegar

Preheat the oven to 350°F (175°C). Spread the rice out on a baking sheet and toast for 45 minutes, stirring occasionally, until golden brown. Meanwhile, place the strawberries in a large bowl and mash to extract the juice. Strain the juice through a fine sieve into a large bowl, reserving the solids.

Fill a large pot with 8 cups (2 liters) of water. Add the reserved strawberry solids and bring to a simmer over low heat. Cook for an hour until you have a lightly perfumed and flavored broth. Strain through a fine sieve into the strawberry juice and stir. Add the toasted rice and sage, cover and leave at room temperature for 2 hours.

Strain into a glass jar, add the rice vinegar and stir. Store in the refrigerator and serve cold.

Q&A:
Benoît d'Onofrio, Le Sobrelier

How did you develop the role of the "sobrelier"?

I started working as a traditional sommelier in 2011. After a few years, I became aware that I didn't have anything interesting to offer people who didn't want to drink alcohol. I tried to be more inclusive in my work, beginning with looking at different kinds of coffee extractions, plant extractions, handcrafted fruit juices. It was only when I stopped drinking myself that I realized these options weren't sophisticated enough to pair with a gastronomic meal; if you didn't drink alcohol, you were missing out on something that can lift up the experience of going to a restaurant.

That's when I realized I was better off crafting my own drinks. Rather than trying to imitate wine or beer, I wanted to emulate the aspects that make them interesting, such as the acidity, bitterness, texture, length, spice.

What are some of the challenges in creating interesting nonalcoholic drinks?

One of the main challenges is fermenting without making something alcoholic. Alcohol creates complex flavors and it fixes the textures and aromas, but it is the fermentation that creates acidity and balances the sugars in a drink, giving an impression of fruitiness rather than sweetness, for example. The key is to keep the amount of sugar as low as possible.

Why should someone go to the effort of making elaborate nonalcoholic drinks?

For one, they are going to be able to offer their guests something that they have never experienced before. With most nonalcoholic drinks, you mostly know what you're going to get—there are ultimately only subtle differences between one brand of orange juice and another. I hope these recipes give a sense of how many possibilities there are left to be explored when it comes to making interesting nonalcoholic beverages.

Do you have any advice for someone trying these recipes?

Don't hurry! Some of the recipes take time to craft but most of that is to allow the drink to develop. Otherwise, there shouldn't be anything complicated in terms of the techniques required or the ingredients—everything should be easy to find at your local grocery store. The other piece of advice I have is to make sure you serve the drinks in elegant glasses—either wine glasses or old-fashioned glasses. It looks better than using a water glass and allows you to taste the drink properly.

WATER WORKS: Make sure to fill a pitcher with water and place it in the fridge while you're cooking, so that it's chilled by the time you're ready to serve food. If you don't have a pitcher, don't worry: Water is the only drink that can be poured before everyone sits down at the table.

2.
WEDDING

S.

S.

WEDDINGS

The Cake: A Modular Cake *You* Can Make

Recipe by Marion Ringborg.

ABOUT:
Marion Ringborg is a Swedish chef and food artist. Before setting up her creative agency, Studio Marion, Ringborg ran Garba—a Gambian-Italian restaurant in Stockholm.

SERVES 20

SPONGE CAKE:
5 pounds (2.2kg) granulated sugar
27 eggs
1½ quarts (1.35l) milk
4 pounds (1.89kg) all-purpose flour
6 tablespoons (90g) baking powder

STRAWBERRY JAM FILLING:
1 pound (500g) strawberries, fresh or frozen
1 cup (200g) granulated sugar
2 tablespoons (30ml) lemon juice

VANILLA CREAM FILLING:
2¾ cups (670ml) milk
3 egg yolks
¾ cup (170g) granulated sugar
3 tablespoons (30g) cornstarch
Seeds scraped from 1 vanilla bean
½ cup (100g) butter, at room temperature

LEMON CREAM CHEESE FROSTING:
1 pound (540g) cream cheese, at room temperature
1 cup (225g) butter, at room temperature
⅖ cups (270g) powdered sugar
1½ tablespoons (9g) lemon zest
3 tablespoons (45ml) lemon juice

FOR DECORATION:
Edible flowers
Edible silver balls

STEP ONE:
SPONGE CAKE

— Preheat the oven to 350°F (175°C). Grease and line three large, rimmed baking sheets with parchment paper.
— In a very large mixing bowl, beat the sugar and eggs together until the mixture is light and fluffy. Gradually add the milk, mixing well until combined.
— In a separate large mixing bowl, sift together the flour and baking powder.
— Gradually fold the dry ingredients into the wet mixture, stirring gently until smooth and well combined.
— Spread the batter evenly across the prepared baking sheets, making sure the layers are around ½ inch thick (between 1 and 2 cm).
— Bake in batches for 20 to 25 minutes, or until a toothpick inserted in the center of the cakes comes out clean. Keep an eye on them to avoid overbaking.
— Once baked, remove from the oven and let cool in the trays for about 10 minutes. Transfer them to wire racks to cool completely.

STEP TWO:
STRAWBERRY JAM FILLING

— In a large saucepan, mash the strawberries with a potato masher.
— Add the sugar and lemon juice, then bring to a boil.
— Cook over medium-high heat, stirring occasionally, for about 15 to 20 minutes or until the mixture thickens.
— Remove the mixture from heat and let it cool completely.

STEP THREE:
VANILLA CREAM FILLING

— In a large saucepan over medium heat, heat the milk until warm but not boiling.
— Meanwhile, in a large mixing bowl, whisk together the egg yolks, sugar and cornstarch until smooth.
— Gradually pour the warm milk into the egg mixture while whisking continuously to temper the eggs.
— Return the mixture to the saucepan and cook over medium heat, whisking constantly, until it thickens and comes to a gentle boil.
— Remove from the heat, add the vanilla seeds and stir in the butter until melted and smooth. Allow the mixture to cool completely.

STEP FOUR:
LEMON CREAM CHEESE FROSTING

— In a large mixing bowl, beat the cream cheese and butter together until smooth and creamy.
— Gradually add the powdered sugar, lemon zest and lemon juice, mixing until smooth and fluffy.

STEP FIVE:
ASSEMBLE THE CAKE

— Once the cakes have cooled, cut them lengthwise down the middle to create two elongated pieces.
— Spread a layer of strawberry jam on one piece of cake and then place another piece of cake on top.
— Spread a layer of vanilla cream over the top layer of cake, and then place another piece of cake on top.
— Repeat this process as many times as you like with the remaining cake pieces to form one elongated cake with multiple layers.
— Frost the cake: Use the lemon cream cheese frosting to cover the entire surface of the cake, smoothing it out as you go with a palette knife.
— Decorate the cake with edible flowers and silver balls as desired.

HOW TO SCALE UP: The beauty of Ringborg's modular wedding cake is that you can make one batch for every 20 guests. The additional batches can be added end-to-end with the original cake using the frosting to smooth over the joins and create one extremely long showstopper. The cake pictured here uses three batches and would serve 60 guests.

ABOUT:
Simone Gooch runs Fjura, a floral design studio based between Sydney and Europe, where she styles arrangements for clients that include Gucci, Hermès and Loewe.

WEDDINGS

The Flowers: Simple Ideas for Stress-Free Florals

Arrangements by Simone Gooch.

Give a Wild Welcome

For a larger centerpiece, which you can place on a welcome table, Gooch recommends selecting a combination of branches from flowering trees, some that have movement and others that are straighter. "Here we used quince and magnolia, which we placed in the middle of the table," she explains. "And instead of using a vase, you can tie the larger branches together to keep them in place, threading other smaller pieces through to create the final arrangement." Make sure to snip the branches to allow space for guests to sign a guestbook, or be able to sit or stand comfortably nearby.

TIMING:
Gooch advises that you might be surprised how much time and effort is involved in creating beautiful arrangements if you're not used to working with flowers. If you are doing it all yourself, expect it to take four times as long as you think it will, or else have four times as many people assist you than you think you need. Many hands make light work—especially on your wedding day.

SEASONAL:
The first step in creating striking arrangements is always to ask your local florist or market seller what flowers are looking best at that time of year. If you are marrying in the winter or in a region where flowers aren't blooming, there are still options. You can design arrangements using branches from local apple and cherry trees, for example, or else dried flowers.

WHEN TO BUY: Unless you're planning to buy your florals on the day of your event, you will need to consider how long different flowers last—and how long they will take to bloom—so that everything looks its best at the same time. Gooch recommends asking your florist or market seller to advise you on what to buy depending on when you need them. This might mean staggering your buying over the course of around five days. Roses, for example, are best a few days after they open, whereas sweet pea, lilac and cyclamen are best bought the day before or even on the day, as they only last a short time and don't change significantly once cut.

Self-Styled Centerpieces:

Make a Commitment

Using one type of flower en mass requires less work than making mixed flower arrangements and can have a stronger visual impact. "It's easier to fuck it up if you have a lot of variety," says Julius Værnes Iversen, a Copenhagen–based floral artist. "It takes a skilled florist to work with 20 types of flowers in a bouquet. My advice to most people is that the less variety, the cleaner the aesthetic."

WHY THESE WORK: When picking a vase for an arrangement, consider the shape and scale of the flower. "Here, the sweet pea suits a short wide vase," says Gooch, "while a vase with a narrow opening and large base keeps the magnolia stem upright and, when filled with enough water, ensures it won't tip over with the weight of the flower."

Show Some Love

After buying your flowers, stems need to be recut and placed into water, and they should be recut and have their water changed daily. "Just like humans, flowers have pores and the temperature of the water you give them can affect how long they last," says Værnes Iversen. "Flowers grown from a bulb, which is most flowers that grow in the winter and spring, need cold water whereas flowers that grow on a root system—mostly perennials or flowers that grow on trees in the summer—need warm water." Another way to tell is if the flower has a soft stem, like a tulip, in which case it needs cold water; if it's hard, like a rose, it needs warm water. Get it right and your bouquet will last three or four times longer.

A NOTE ON PLACEMENT: Gooch says it's important to always consider your guests and catering. Low arrangements will ensure that your guests can see each other across the table; if there is some height to your centerpiece, make sure it is sparse enough to allow people to make eye contact. It's also important to think about how much room to leave so there is space for the table settings.

WORDS:
JULIUS VÆRNES IVERSEN

How to Build Your Own Bouquet:

VARIETY:
I find that making a bouquet can feel like you are crafting an extension of yourself and comes quite naturally, but there are some key elements to take into consideration. As a general rule, work with three to four flowers. Less is better—it will give you a cleaner look and be easier to control.

SPACE:
When you look at a perennial garden or a flowering tree, you'll see that the flowers are not all grouped together. Of course, it's not possible to do it on the same scale as you would have in a garden, but you want to try give the flowers in a bouquet the same free space they would have in nature. It's a way of thinking that comes from the Japanese art of ikebana, a meditative form of flower arranging that requires you to respect each individual flower.

SHAPE:
The biggest mistake florists make when creating a bouquet is to be too controlled. For a more organic bouquet, use flowers that are different heights and create different levels within the bouquet or arrange them with more dynamic shapes, like diagonals.

COLOR:
I often use contrasting colors from within the same color family, like a very light yellow and a dark red for warm tones, or blue and a dark purple for cold tones. And I always use a lot of green, to reflect how these plants grow in the wild.

VESSEL:
You can use a beautiful vase for your bouquet, but I personally prefer to create decorations without a vase. I feel that the artists and designers who make them deserve to not have flowers overshadowing their work. Rather than use flower foam, which contains microplastics, I create a form in chicken wire, into which I place reusable plastic tubes that I fill with water and the flowers. It also means the flowers last longer than they would do in flower foam.

Don't Sweat the Small Stuff

Posies

For posies, Gooch suggests selecting flowers that will not perish too quickly out of water, like this simple porcelain white cyclamen. Keep the flowers in water until the very last minute. When you're ready to create the arrangement, tie the stems together tightly with string and cut the ends so they are all the same length. Dry the stems thoroughly with a towel, to avoid water dripping on to your clothes, and wrap with a ribbon to cover the string.

Boutonnieres

"Boutonnieres are best left to the professionals," Gooch says, "as they involve the use of wire to create a structure to support the flower." If you do decide to make your own, she recommends taking a single flower, wrapping its stem with a very thin ribbon, and securing it in the buttonhole with a pin. Make sure to use a flower that can be out of water for some time, is not too heavy and sits relatively flat against the chest. Having extra flowers, ribbon and pins on standby is recommended.

The Art of Candlescaping

A candlescape—a curated arrangement using candles—is a great way to make the atmosphere more intimate, create a focal point and cast your guests in a flattering light. It could be as simple as placing a single elegant candle and holder styled on a table with beautiful tableware, or you could combine candles and holders of different sizes and heights. "Candles are always part of my action plan," says stylist Maria Flores, interviewed overleaf. "What's really hard about doing a tablescape is finding visual harmony. Candles help balance everything out."

Wait until 10 minutes before your guests arrive to light the candles, so that the wicks have time to burn, and if you're relighting a candle, trim the wick with scissors to be around ¼ inch (6mm), to ensure it burns evenly and efficiently. Most importantly, make sure to keep an eye on them during the party so that your hard work—and your party—doesn't go up in flames!

When it comes to tidying up, use a bag of ice to harden any wax that has fallen on the tablecloth and scrape it off with blunt knife. If there is still a stain, place the tablecloth on an ironing board with a few sheets of paper towel on top of the stain, and iron until all the wax has been absorbed. Stubborn candle ends can be removed by soaking the holder in warm water and the careful use of a corkscrew—don't throw the candle ends away! When wrapped in paper towel, they make for great firelighters.

WEDDINGS

The Focal Point:
How to Source Decor at the Grocery Store

A little reverence for raw produce can go a long way.

ABOUT:
Maria Flores is the founder and creative director of Oh, Maria Flores, a flower design studio in Lisbon that specializes in creating sculptural arrangements for weddings and events.

Q&A: Maria Flores

Your studio creates sculptural tablescapes with fruits and vegetables. How often do your clients request these?
I'm starting the second half of the wedding season and, now that I'm thinking about it, we have fruits and vegetables in almost all of our events.

Why are they suddenly so popular?
Events are highly curated now and everyone wants something different. It's such a talking point for the guests, especially when we incorporate things that the couple loves.

Do you have any advice for people wanting to make their own edible sculptures?
They may seem pretty easy, but they're not—especially if you're a beginner. Try it out a couple of days before your party and see how things hold. You don't want to be stressed about the decoration, right? I'm imagining someone trying to make a candleholder out of an eggplant last minute and losing their mind!

What equipment do you need?
Find yourself some kenzans [also known as flower frogs]—that's what we use most of the time. They're really helpful just to keep the veggies standing up. Toothpicks are a big part of this too.

Are there any golden rules to follow?
I love a monochrome table. It's always so much easier, especially if you're just starting out. Choose one color, go to the supermarket and then just go for it. The last thing we were looking for was Indian cucumbers. They have these really different textures and shapes to work with.

What else are people requesting?
Everyone is big on allium at the moment. A lot of people don't know it, but the allium family includes garlic and onions.

Wouldn't that smell?
Almost every wedding in Lisbon is outdoors, so it's fine. And things like allium and citrus are actually great bug repellents. I'll try to avoid anything smelly. It's a good thing to always keep in mind.

Is there any produce that doesn't work well?
We did a cactus table, which I deeply regret. We were all just lashing out at each other in the studio, screaming, "Why are we doing this?" And I was like, "I don't know!"

How do you avoid food waste?
You should prepare for that. My studio is in a residential area, so I have loads of neighbors and everyone gets a box after the event. I'll call them and say, "Please find some room in your fridge." Sometimes, I'm just in the street asking people, "Do you want this? Do you want that?" Nothing goes to waste.

149

3.
SOIREES.

SOIREES

The Welcome:
Two Shots You Won't Regret

Recipes by Rebekah Peppler.

ABOUT:
Rebekah Peppler is an American writer and food stylist who lives in Paris. Her latest cookbook, *Le Sud*, explores the culinary culture of the south of France.

Petite Sour

As your guests arrive, exchange their coats for small, chilled glasses of a petite sour. The classic sour template—spirit, citrus, sweetener, water—can be traced to the mid-19th century, and the balance of sweetness and acidity can handle a wide variety of base spirits (think whiskey sour, daiquiri, gimlet, amaretto sour). For this bright, balanced, welcome-sized pour, choose between gin or vodka, place a selection of small glasses in the freezer about an hour before your guests arrive, and time your shake for the first arrival.

MAKES EIGHT 1½-OUNCE SHOTS

Ice
6 ounces gin or vodka
2¼ ounces fresh lemon juice
2¼ ounces 1:1 simple syrup
4 2-inch strips of lemon peel

In an ice-filled shaker, add the gin or vodka, lemon juice and simple syrup. Cover and shake until chilled then strain into the chilled glasses. Hold a lemon peel, skin facing down, over two glasses and pinch to express the citrus oils. Discard the peel and repeat with the remaining glasses.

NICER ICE: Placing colorful, edible flowers in your ice cube trays is a fun and easy way to add interest to your guests' drinks. It works best if the ice is completely clear, but this can be surprisingly tricky to achieve (sadly, contrary to popular belief, it is not as simple as just boiling the water first or using distilled water). If you have the space in your freezer, you can create clear ice at home by harnessing directional freezing, where the ice freezes slowly in one direction, pushing out all the impurities. Fill a cooler about ¾ full of water and place in a freezer without the cooler lid. After around 12 hours, the water should have frozen almost all the way through. There will be a small cloudy section of impurities that have sunk to the bottom, which you can easily chip off. Remove the ice from the cooler and use a sharp point to break the ice as and when you need it.

Another petite pour that is perfectly fit to open the evening is the doudou. This Lebanese shot incorporates all the definitive components of the spicy, briny shooter: vodka, lemon, olive brine, hot sauce—as well as an added layer of bright, salted preserved lemon brine. Swap the vodka for gin if you like (which will make it more floral and botanical in flavor) or alter the spice level by adding more or less Tabasco. Poured ice cold from shaker to shot, the doudou is traditionally served alongside an olive chaser to provide a sophisticated—and spirited—welcome.

Doudou

MAKES EIGHT 1½-OUNCE SHOTS

Ice
6 ounces vodka
3 ounces fresh lemon juice
¾ ounce green olive brine
½ ounce preserved lemon brine
10 to 12 dashes Tabasco
Green olives, for serving

In an ice-filled shaker, combine the vodka, lemon juice, olive brine, preserved lemon brine and Tabasco. Cover and shake until chilled. Strain into the chilled glasses and serve immediately with olives.

SOIREES

The Snacks: Two-Bite Hors d'Oeuvres

Recipes by Easy Peacy.

EASY PEACY:
For more recipes by Easy Peacy, turn to page 120 for their sharing dishes for small gatherings.

Gildas

MAKES 12 GILDAS

12 toothpicks
24 large green olives, pitted
12 anchovies
12 ½-inch slices of Spanish chorizo
12 pickled chili peppers
Extra-virgin olive oil
Flaky sea salt

On a toothpick, skewer an olive, an anchovy, another olive, a piece of chorizo and a pickled chili. Repeat with the remaining ingredients. Arrange on a platter, drizzle with olive oil and sprinkle with salt.

TIPS ON HOSTING:

I believe in the simple things that transform the feeling of a room: lighting candles, dimming the lights a bit, having a fire in the hearth. I love to have a basket of beautiful fruits or vegetables from the market on the kitchen table—things like gypsy peppers, beautiful purple onions, heirloom tomatoes or chicory lettuce, depending on the season. I also keep a large vase in the corner of the kitchen for arranging seasonal flowers. The basket and vase are what inspired Permanent Collection's "Alice's Kitchen Basket" and "Alice's Amphora" respectively. And I have an oval table because I love to have people sitting together that way—it feels warmer and more inclusive.
ALICE WATERS
@alicelouisewaters

This one's for my fellow Type A's out there: Don't kill yourself in the kitchen. In my experience, most guests aren't at your dinner to have the most spectacular meal they've ever had. They're there to shmooze or catch up. I promise you, no one cares as much as you do.
ROB LI
@broccoliraab

You've got to be organized. You don't want to be stuck in the kitchen all evening, so get everything cooked as far in advance as you can. And before your guests arrive, make sure the table is laid, you've got the glasses out and you have a good playlist going—something relaxing and chilled.
THOMAS STRAKER
@thomas_straker

I love to have a task to get on with when people are over. My partner is a brilliant host and will chat and pour wine all night, but if I get a little anxious or need a couple of minutes to myself, I can sneak over to the stove and briefly lose myself in cooking a piece of fish or chopping chives. I find it grounding. Little moments like that keep myself and my guests relaxed and having a good time.
BEN LIPPETT
@dinnerbyben

I've seen so many hosts stress about how everything needs to look. Hosting is like hugging people: Put intention and care into your actions and let people feel it.
DANIEL SOSKOLNE
@lev.nyc

Croustades with Parmesan Cream and Fried Sage

MAKES 12 CROUSTADES

1 bunch sage
2 cups (500ml) heavy cream
3½ to 7 ounces (100 to 200g) Parmesan rinds or pieces
4 bay leaves
10 peppercorns
¾ cup (200ml) canola oil, for frying
Fine salt
12 mini pastry cases (can be purchased in well-stocked supermarkets)

Set aside 12 to 15 nice sage leaves. In a medium saucepan over medium heat, bring the cream, Parmesan rinds, bay leaves, peppercorns and the remaining sage to a boil. Reduce to a simmer for 10 to 15 minutes. Strain the cream, discarding the parmesan rinds and other solids, and pour into a bowl. Refrigerate until cold.

Heat the canola oil in a small saucepan. Once hot, fry the reserved sage leaves for about 5 to 10 seconds, ensuring they do not turn brown. Carefully remove the leaves, place them on a small paper towel–lined plate and sprinkle with salt.

Whip the chilled Parmesan cream with an electric mixer until it has the consistency of thick whipped cream. Season with salt to taste and transfer the cream to a piping bag.

To assemble, arrange the mini pastry cases on a plate. Pipe the Parmesan cream into the center and top with a fried sage leaf.

Langoustine Toast

MAKES 12 TOASTS

1 pound (450g) langoustine (or lobster) tails (weight without shell)
4 teaspoons fresh ginger, peeled and chopped
2 spicy green chilies
3 or 4 cloves garlic
6 eggs
¾ cup (200ml) heavy cream
Flaky sea salt and freshly ground pepper
12 slices bread
Canola oil (or similar)
Chopped fresh basil or thyme, for garnish

Peel and clean the langoustine tails. In a blender, combine the langoustine tails with the ginger, chilies, garlic, eggs and cream and blend until smooth. Season generously with salt and pepper. Spread a good layer of the mixture on each slice of bread, heat a little canola oil in a pan and fry in batches, coated side down, until golden. Flip and cook on the other side until golden. Halve or quarter the toasts and sprinkle with fresh herbs and salt and pepper.

If making in advance, reheat in the oven at 400°F (200°C) for 3 minutes before serving.

Deviled Quail Eggs

MAKES 12 EGGS

¾ cup (200ml) white wine vinegar
12 quail eggs
6 chicken eggs
4 tablespoons mayonnaise
2 teaspoons Dijon mustard
¼ teaspoon paprika, plus more for garnish
5 drops Tabasco sauce
2 tablespoons extra-virgin olive oil
Salt and pepper

Prepare a bowl with the vinegar and ice cubes. Fill a medium pot with a few inches of water and bring to a boil. Place the quail eggs in the pot and boil for four minutes. Remove them from the pot (reserving the water) and place in the vinegar/ice bowl. Once cooled, peel the quail eggs carefully and set aside.

Bring the water back to a boil, place the chicken eggs in the pot and boil for 8 minutes. Remove from the pot, cool under cold running water and peel. Remove the egg whites (and save for another use). In a medium bowl, mash the yolks with the mayonnaise, mustard, paprika, Tabasco (to taste) and olive oil. Mix well until creamy. Season with salt and pepper.

To assemble, fill a piping bag with the egg mixture. Stabilize the quail eggs on a serving plate by placing them on a small dollop of the egg mixture. Pipe the mixture in a decorative pattern on each quail egg and finish by dusting with paprika, using a fine sieve.

SOIREES

The Drinks: Easy Twists on Classic Cocktails

Recipes by Rebekah Peppler.

The Punch Bowl

This citrusy punch, made with Cognac, fino sherry and Lillet Blanc, is the perfect celebratory centerpiece; rich yet bright, spirited yet balanced. Start by making the oleo-saccharum—citrus peels and sugar that are muddled together and left to sit—a day or two in advance for a simple and flavorful base from which to build your drink.

Should you be planning to serve your large-format punch over equally large-format ice, be sure to also freeze water in your chosen vessel—be it a Bundt pan, loaf pan or fluted mini cake pan. Once guests have gathered, ladle the punch into individual ice-filled glasses and finish with a final flourish of sparkling wine. For a lighter alternative, add a splash of chilled tonic water in lieu of the wine.

To make the oleo-saccharum (Latin for "oil-sugar"), peel the lemons and grapefruit and place the peels in a bowl, reserving the rest of the fruit in the refrigerator. Add the sugar and salt and use a muddler or the end of a rolling pin to press and mix firmly until the peels begin to release their oils and turn slightly translucent. Cover and leave at room temperature for at least 6 hours.

MAKES ABOUT SIXTEEN
4-OUNCE DRINKS

3 lemons
1 large grapefruit
¾ cup (150 grams) sugar
A pinch of flaky sea salt
6 ounces fino sherry
6 ounces Cognac
6 ounces Lillet Blanc
Ice (see Note)
One 750ml bottle dry sparkling wine, chilled

Juice the reserved lemons and grapefruit (you should have about 10 ounces of juice) and add to the oleo-saccharum. Stir until the sugar dissolves and strain through a fine sieve, pressing out all the liquid. Store in the fridge for up to a couple of days.

The punch should be prepared at least a few hours in advance: Combine the mixture with the fino sherry, Cognac, Lillet Blanc and 10 ounces of cold, filtered water. Stir to combine then cover and chill.

To serve, add the ice blocks to a large punch or serving bowl and pour in the punch. Ladle about 3 ounces of the punch base into ice-filled glasses and top with 1 to 2 ounces of sparkling wine.

To make ice blocks or rings: At least a day (or up to a few days) before you plan to serve the punch, add enough water to come halfway up the sides of your chosen vessel and freeze overnight. If you want to add citrus wheels and/or rosemary sprigs, add enough water to come an inch or 2 up the sides of the vessel then add edible decorations and freeze for a few hours. Once the decorations are frozen into place, add enough water to come halfway up the sides and freeze overnight.

165

Amaro Boulevardier

The Boulevardier is the superlative cold-weather drink. The sharp, rich combination of rye or bourbon, sweet vermouth and red bitter served straight up or on the rocks acts as balm from first frost to false spring. Amaro can winterize your drink even further. A wide variety of amaro work, from the sweeter, more citrusy Nonino or Averna, which play lighter and brighter in the glass, to stronger, more bitter alpine amaro (such as Bràulio) for a heavier, more forceful drink. Choose according to personal preference and continue to pour all season long.

MAKES 1 DRINK

Ice
1½ ounces rye or bourbon
¾ ounce sweet vermouth
¾ ounce red bitter, such as Campari
¾ ounce amaro
1 2-inch strip of lemon peel, for garnish

In an ice-filled mixing glass, add the rye or bourbon, vermouth, red bitter and amaro. Stir until chilled then strain into a chilled coupe, a Nick and Nora glass or an ice-filled rocks glass. Hold the lemon peel by its long edges, skin down, and pinch to express the citrus oils before adding to the glass.

Calvados & Tonic

This take on a gin and tonic swaps out the gin for Calvados, an apple (or pear) brandy made in Normandy. The brisk, refreshing combination is tempered here with a citrusy pour of orange liqueur and can easily be served from afternoon apéro through to the end of the night.

MAKES 1 DRINK

1½ ounces Calvados
½ ounce orange liqueur
2 dashes orange bitters (optional)
Ice
4 to 5 ounces dry tonic water
Orange twist, for garnish

Add the Calvados, orange liqueur and orange bitters (if using) to an ice-filled highball glass and top with tonic. Garnish the drink with the orange twist.

Lambrusco 75

Switching out sparkling wine for dry Lambrusco and adding rosemary to the simple syrup transforms a classic French 75 into a bubbly, ruby-hued cocktail, perfectly suited for toasting near a fire on a cold winter night. Just as the French 75 can be made with either gin or Cognac, so too can the Lambrusco 75 (the gin iteration will be more botanical and bright; the Cognac richer and more robust).

When choosing a Lambrusco, opt for a dry or off-dry bottle and then pick according to the flavor profile you're inclined toward. Lambrusco di Sorbara, for example, is high in acid and light in color and flavor while Lambrusco Grasparossa is tannic, dark and berry-forward.

MAKES 1 DRINK

Ice
1½ ounces gin or Cognac
½ ounce fresh lemon juice
¼ ounce rosemary simple syrup (see below)
3 ounces dry Lambrusco
Lemon twist or sprig of rosemary

In an ice-filled shaker, combine the gin or Cognac, lemon juice and rosemary simple syrup. Cover and shake vigorously until well chilled. Strain into a champagne or coupe glass and top with Lambrusco. Finish with a lemon twist or sprig of rosemary.

ROSEMARY SIMPLE SYRUP:

MAKES 1½ CUPS

Combine 1 cup (235 ml) water with 1 cup (200 grams) sugar in a small saucepan. Add the peel of 1 lemon, 3 sprigs of fresh rosemary and a pinch of salt. Set over medium-low heat and warm, stirring occasionally, until the sugar and salt are dissolved. Set aside for 10 minutes to infuse, then remove the rosemary sprigs and cool the syrup to room temperature before using.

4.
HOLIDAYS

HOLIDAYS

The Tradition:
Recreate Your Home with Gingerbread

Recipe by Tea Malmegård.
Food Styling by Marion Ringborg.

ETT HEM:
Ett Hem is a luxury hotel in Stockholm's Östermalm district, established by Jeanette Mix in 2012. Chef Tea Malmegård has been making a gingerbread version of the hotel since 2014.

QUICK QUESTION:
The gingerbread house at Ett Hem has become an annual tradition. What does it add to the hotel over the holidays?
There's always a lot of excitement when it arrives. It's as important as the Christmas tree! It brings in family values, becomes a conversation piece and reinforces our Christmas traditions, creating a sense of belonging and strengthening our bond with our guests.
—Jeanette Mix, owner of Ett Hem.

I make the gingerbread house for Ett Hem in Stockholm. It's always based on the hotel, but one year it might be more realistic, another more playful. I love to add all the charming little details: the street sign on the corner of the building, the little balcony, the Christmas lights.

How long a gingerbread house stays edible will depend on how clean your house is—sugary surfaces attract a lot of dust from the air. A couple of weeks over the holidays should be fine, but there might be a reason someone implemented the tradition of breaking our gingerbread houses on *tjugondag Knut* (20 days after Christmas).

GINGERBREAD DOUGH:
1 cup (200g) granulated sugar
2 cups (700g) golden syrup
1¾ cups (400g) salted butter
3 eggs
9½ cups (1,200g) all-purpose flour, plus more for kneading
2¼ teaspoons (10g) baking soda
1½ tablespoons (20g) ground cinnamon
1½ tablespoons (20g) ground cloves
2¼ teaspoons (10g) ground ginger
¼ teaspoon (1g) salt

ICING:
3 egg whites (90g)
3 to 4 cups (600 to 800g) powdered sugar

CARAMEL:
1½ cups (300g) granulated sugar

To make the gingerbread dough: In a medium saucepan, melt the sugar, golden syrup and butter together over low heat, stirring occasionally. Once melted, remove from the heat and allow to cool before whisking in the eggs. In a large bowl, mix together the flour, baking soda, cinnamon, cloves, ginger and salt and pour the liquid mixture into the center. Mix together with a wooden spoon, then knead the dough in the bowl by hand for a few minutes with your hands. Knead by hand for another minute on a lightly floured surface until it is shiny and smooth. Cut into equal parts and flatten them to be 1/16-inch (2 to 3 mm) thick. Wrap these pieces carefully in plastic wrap and place in the refrigerator for at least an hour.

Preheat the oven to 340°F (170° C). While still cold, use a rolling pin to roll out the dough on a lightly floured surface and cut approximately ½ inch (1 cm) outside your template (these can easily be found online), as the cookies will shrink slightly in the oven. Line baking sheets with parchment paper. Place the cookie pieces on the baking sheets, taking care to not place different sized pieces on the same baking sheet as they require different baking times. Bake one piece at a time for between 10 and 12 minutes, or until golden brown—it's important that the gingerbread is properly baked so it doesn't soften. Remove from the oven, carefully cut out any windows using a sharp knife, and leave to cool completely.

To make the icing: In a large bowl, whisk the egg whites and powdered sugar until firm. Add to a piping bag.

To make the caramel: Heat a frying pan—ideally one that is large enough for you to dip the ends of the gingerbread pieces in—over medium heat and sprinkle on thin layers of the sugar until it melts. Continue until all the sugar is a caramel color, stir occasionally with a wooden spoon and reduce to the lowest heat to ensure the caramel stays hot while you assemble the house.

To assemble: Prepare the cutting board or tray you will build your house on and make sure you have all the parts of the house in front of you before you begin. Do any decorating before you start to assemble—it is much easier to do detailed works with the pieces lying flat.

Dip one of the sides of the pieces that you want to join together in the hot caramel (if your pan is not big enough, use a wooden spatula to spread the caramel), push the pieces together and hold until the caramel sets. Start with the walls and once they have been joined, take some extra caramel to set the house firmly on the base. Then connect one piece of the roof at a time. Do not apply too much caramel at once, as it can soften the gingerbread, and try to work "inside" the house to minimize the caramel that's visible from the outside.

SIMMER POT:
Also known as a "stovetop potpourris," simmer pots are an easy way to infuse your home with the holiday spirit. Simply set a large pot of water on the stove, bring to a gentle simmer and add aromatic ingredients of your choice—or just whatever you have to hand. Sliced citrus fruit, herbs like rosemary and thyme, peppercorns, cinnamon and cloves will all help set the mood.

Five Games To Play Over the Holiday Season

NUMEROLOGY
I haven't ever really done party games, but when I feel like it, I give numerology readings. It's very fun agreeing or disagreeing with the different interpretations.
ERCHEN CHANG
@bao_london

CARROM
I love to play carrom, a four-player board game that involves potting little shiny disks with a flick of your fingers. I love how it unites old and young players, and the most unassuming auntie or young kid will turn out to be a wonder.
CYNTHIA SHANMUGALINGAM
@rambutan_ldn

"WHO IS 35?"
A game my mate Dan likes to play is trying to guess which celebrities are a certain age. So, someone throws out an age, "Who is 35?", and then the crew have to taking turns coming up with names. It sounds really easy, but it's actually really tricky. When you come within a few months of being right, it'll drive you mad.
BEN LIPPETT
@dinnerbyben

15-20
A Chinese drinking game called 15-20. It's a guessing game where, at the same time as you call out a number—a multiple of five between zero and 20—people have to try to guess it by opening and closing their hands: One open hand equals five, two hands equals 10, a closed hand means zero. There are many strategies: Some like to be fast and confusing, others are deliberate and will almost trick you into doing what they want you to do. It's a great game for the end of an evening.
JON KUNG
@jonkung

IBBLE DIBBLE
I don't do party games very often, but of all my childhood Christmases there was one particularly warm and merry one (when I was of an age just to start drinking) when we played Ibble Dibble. I have the fondest memories of raucous laughter and goodwill. It is a somewhat ridiculous, and preposterously British, game. The rules are a little complicated, so best to look them up online.
JACOB KENEDY
@jacobkenedy

NON
I'm Parisian. I drink wine at parties. I don't play, haha.
ANDREA SHAM
@andrea.sham

P.113 — 175

Credits:

P. 116–119
Photos: Annika Kafcaloudis
Set Design: Stephanie Stamatis

P. 121–127
Photos: Frederik Lindstrøm
Food Styling: Easy Peacy
Set Design: Tine Daring

P. 129–133
Photos: Christian Møller Andersen
Set Design: Sofie Brunner

P. 137–139
Photos: Pelle Crépin
Food Styling: Marion Ringborg
Set Design: Niklas Hansen

P.141–146
Photos: Phillip Huynh
Floral Styling: Simone Gooch
Set Design: Mariska Lowri

P. 147
Photo: Frederik Lindstrøm
Set Design: Tine Daring

P. 149–151
Photos: Annika Kafcaloudis
Set Design: Stephanie Stamatis

P. 155–157
Photos: Christian Møller Andersen
Set Design: Sofie Brunner

P. 158–163
Photos: Frederik Lindstrøm
Food Styling: Easy Peacy
Set Design: Tine Daring

P. 164–169
Photos: Christian Møller Andersen
Set Design: Sofie Brunner

P. 172–175
Photos: Pelle Crépin
Food Styling: Marion Ringborg
Set Design: Niklas Hansen

Styling Notes:

P. 129
Coupe by Louise Roe. Tray by Valerie_Objects. Kitchen by Reform.

P. 130
Glass by Louise Roe.
Tray by Montana.

P. 131
Glass by Stilleben. Straw by H. Skjalm P. Plate by HAY.

P. 133
Carafe by Helle Mardahl Studio. Glasses by Ørskov at H. Skjalm P. Cutting board by HAY. Kitchen by Reform.

P. 147
Bowl by BLÆS. Wine glass, flute and goblet by Cordius Glas at Kræss. Pitcher by Simon Manoha at Tadaima. Glass by Nina Nørgaard at Tadaima. Plate by Joe Christopherson at Yonobi. Teaspoon by Corali at Tadaima.

P. 155
Glasses by Louise Roe. Cutting board by HAY. Tray by Montana. Kitchen by Reform.

P. 157
Glass by Karakter.

P. 159
Plates by Joe Christopherson at Yonobi. Glass bowl by BLÆS.

P. 160
Tray by Natalia Criado at Tadaima. Tumbler by BLÆS. Plates by Joe Christopherson at Yonobi. Champagne flute by Cordius Glas at Kræss. Frosted cup by Nina Nørgaard at Tadaima. Glass by Szklo Studio at Tadaima. Cup by Natalia Criado at Tadaima.

P. 162
Platter by Normann Copenhagen.
Tray by Natalia Criado at Tadaima.

P. 165
Glasses by Karakter. Bowl by Helle Mardahl Studio. Spoon by H. Skjalm P. Cutting board by HAY.

P: 166
Glass by Karakter.
Straw by H. Skjalm P.

P. 167
Glass by Ørskov at H. Skjalm P. Spoon and container by David Mellor at Tadaima. Cutting board by HAY.

P. 168–169
Coupe by Karakter.
Jigger by H. Skjalm P. Plate by Helle Mardahl Studio.

Unless stated above, all other items are vintage or from the stylists' own collections.

178	Field Notes
179	Power Tool
180	On the Shelf
182	Crossword
184	Received Wisdom
188	Seasonal Produce

Directory.

FIELD NOTES

Words:
Amanda Thomson

A guide to reading the winter sky.

The quality of light changes as winter sets in. In December, the midwinter sun is low—when it makes an appearance at all—and the shadows it casts are long; light feels precious and fleeting. The air changes too; as it gets colder, sound travels farther. You might be able to make out a faint honking as skeins of geese travel south to their wintering grounds.

On moonless winter nights, skies can be impossibly full of stars. In the Northern Hemisphere, the Big Dipper's pan, Cassiopeia's "W" and Orion's Belt are the easiest constellations to pick out. Sometimes a dot of light will seem more solid and a pair of binoculars will reveal that these are planets; you might even be able to make out the moons around Jupiter or the thin lines of Saturn's rings. Venus, low in the sky, is a steady bright spark visible to the naked eye. The vast sweep of the Milky Way lives up to its name. And tiny motes of satellites drift slowly with unknown purpose, high above.

A cloudless night might also hold the promise of the northern lights, when the sky will start to ripple with curtains of iridescent greens, oranges and reds. Usually occurring north of 60 degrees latitude, they can sometimes be seen much farther south. In the dialect of the Shetland Islands, they're known as the *mirry* dancers, the word *mirr* meaning to shimmer; in Scots Gaelic, they're *na fir-chlis*, the nimble ones, and are said to be a sign of faeries dancing. Some Scandinavian fishing cultures thought they were the effect of light reflecting off huge shoals of herring and a sign of good luck. The Inuit believed they were the spirits of the dead.

The phenomenon can be easily explained by science—the product of electromagnetic storms and solar winds—but even if we no longer ascribe this spectacle to otherworldly forces, the lights remain a miraculous reminder of the wonder we seek in the sky.

—
—

POWER TOOL

As Told To:
Rebecca Thandi Norman

House of Finn Juhl co-founders IVAN HANSEN and HANS HENRIK SØRENSEN on designer Finn Juhl's use of wood.

In Denmark, the use of wood is functional: We have wood, so we use it. But Finn Juhl didn't come from the school of functionalism. Juhl's pieces are all about feeling.

Juhl had wanted to study art history but his father wouldn't let him; architecture was a compromise. You can see that love of art in his designs, how he's interested in the human and the organic—especially in the way he used wood: The touch, the shape, even the color of it is at the core of his work. He had no idea of the limitations of material, but that let him be a pioneer. He would draw what he wanted and eventually found a cabinetmaker who was talented enough to bring his vision to life.

We started House of Finn Juhl in 1999 because Hanne Wilhelm Hansen, Juhl's widow, wanted us to produce one of his sofas. We're not craftspeople but we had the network, we knew the people with the skills. Key to that is how we source our wood, not just because of sustainability and ethics—that is, of course, essential—but also because, like Juhl, we know that the feel and quality of the wood is important.

We mostly work with American walnut and oak, in both solid wood and veneer pieces. People misunderstand sometimes but veneer is 100 percent wood; it's just thin, so it's easier to work with on flat elements, such as a tabletop or on shelves. Juhl has lots of pieces that combine veneer and solid wood, and some even combine different types of wood too.

Carrying Finn Juhl's legacy is a huge honor, but it's not heavy. The great thing about his work is that it's playful, and we continue to include that feeling in the way we present his designs today.

Photo: Simon Baungård

Photo: Christina Webber

ON THE SHELF

Words:
Kabelo Sandile Motsoeneng

CAMILLA GRUDOVA on getting gross with fiction.

For Camilla Grudova, a short story is a "vision" through which she explores the society we live in. In her celebrated collections, *The Doll's Alphabet* and *The Coiled Serpent*—as well as her novel, *Children of Paradise*—Grudova poses difficult and awkward questions, such as: Where does all the waste go once we expel it from our bodies? How do institutions of power perpetuate themselves? Where have all the insects gone in the last few years? Ultimately, the Canadian-born, Edinburgh-based writer—who was named as one of *Granta*'s Best of Young British Novelists in 2023—wants readers to come up with their own answers.

KABELO SANDILE MOTSOENENG: Ordinary, unassuming places tend to morph into the grotesque in your work. How do these places—real or imagined—inform your writing process?

CAMILLA GRUDOVA: I'm drawn to an architectural space as the beginning of a story. If you work in bars or cinemas, you have to clean the bathrooms—that's where you realize just how chaotic human beings are.[1] I think it's because I'm a Libra as well: I'm highly sensitive to my surroundings.

KSM: The stories in *The Coiled Serpent*, like most of your fiction, deviate from "traditional" form. How did you arrive at this approach?

CG: A short story doesn't have to follow a neat narrative. You're putting a very specific vision in someone's head and because the mind is a dense and intense space, you have to give the reader something flavorful. I like to compare a short story to an oil or pungent cheese; it's an experience that goes straight into your mind.

KSM: How did you come to use horror as a way to dramatize complex issues—abuse of power, capitalism, legacies of colonialism?

CG: I don't think I consciously ever thought I was writing horror. I like to tap into late-stage capitalism and what it does to people, and use historical lenses to look at contemporary things. "The Green Hat" [a story in *The Coiled Serpent*] was inspired by the use of arsenic in 19th-century dyes—a lot of these ended up being quite toxic. It is interesting to think that there could be many things that are toxic to people today that we don't know about, whether it's TikTok or chemicals we're using. But I never want to be didactic. I find that a bit boring. I'd rather present a situation.

KSM: "Ivor," from *The Coiled Serpent*, is about a collective obsession with the eponymous character at a boy's boarding school. What drew you to that subject matter?

CG: I'm definitely an outsider looking in at these relationships, especially of the Edwardian era. I used to be obsessed with *Maurice* by E.M. Forster.

KSM: I got the *Maurice* vibes!

CG: "Ivor," in particular, was inspired by *Downhill*, a Hitchcock film with Ivor Novello, an actor I really love. It's a simple moral story where Novello plays a boarding school boy who covers for his friend's indiscretion. He's expelled and then lives a scandalous life in Paris. In the end, he's allowed back into the school. I was also hanging around with a lot of these boarding school guys and seeing how they retained their childhood. They never moved on; that was the high point of their lives.

KSM: Your three books focus on issues as varied as waste management, labor and femininity. What's your next project about?

CG: I like to zoom in on details and the short story is a good form to do that. I'm really interested in objects because I studied art history—I like to tap into the history of the things they have seen. At the moment, I'm obsessed with the insect crisis. They are disappearing at a rapid rate and I find it quite terrifying. *The Doll's Alphabet* has a story about a [half-man, half-]spider. I'm returning to the subject because insects are considered so insignificant when they have such a significant role—I'm interested in how such tiny things relate to the bigger picture.

KSM: Which of your books would be an ideal starting point for new readers?

CG: Maybe *The Doll's Alphabet*. It is kind of shallow water in comparison to where I was going with the grossness in the other books. *The Doll's Alphabet* will acclimatize the reader to the general vibes of the work, then they can wade into *The Coiled Serpent*, which can be pretty disgusting at points!

(1) Grudova's debut novel, *Children of Paradise*, follows Holly, an employee at an old cinema called the Paradise whose responsibilities include cleaning the filthy bathrooms.

PARTY GAMES:
It's time to play fest and loose.

Mark Halpin

ACROSS

1. Pyramid scheme, e.g.
5. First-string players
10. Angle
14. Supergirl, to friends
15. Something you can see in España
16. Region or field of expertise
17. Muslim leader
18. Campfire remnant
19. Ensuing
20. One crazy about being the center of attention at a party?
23. Rectitude
24. Romantic assignations
28. Working without _____
29. "Lobster Telephone" artist
31. Notable time
32. Sizeable wardrobe
35. Puffin-like bird
36. Party that's on and then off?
41. Six-pack components
42. A nice piece of change
43. Mousse alternative
44. Detest
45. Ingredient in a vegan stir-fry
48. Quite a sight
50. Punishing Old Testament–style
53. When a party ends in an unexpected or ironic way?
56. Range of choices
59. Ancient theater or cinema name
60. "Terrible" tsar
61. Bakery fixture
62. Email option
63. Geom. shape
64. Stage that might be buggy
65. Bush and Moss, etc.
66. Wapitis, among others

DOWN

1. Pinch pennies
2. Smartphone feature
3. Catalonia neighbor
4. Fairy-tale matriarch
5. Worried persistently
6. Shaun the Sheep's little cousin
7. Idris of "The Wire"
8. Arabian port city
9. Like a frivolous court case
10. Take a shine to
11. Anger
12. Census info
13. Panama, for one
21. Tall order in a British pub
22. Pop star Grande, to fans
25. Blacken on the outside
26. Make level
27. Sushi bar drink
29. Semiconductor device
30. Pretentious
33. Wrought iron and the like
34. "Right away, boss!"
36. Guru or wise man
37. Follow orders
38. Sicily or Sardinia
39. Not currently stocking
40. 1985 Springsteen hit
44. Rustic dwelling
46. Young Mousekewitz of animated films
47. Remove from a bulletin board, perhaps
49. Local animals
50. Took the wrong way?
51. Awards for Broadway's best
52. Sign on many a loo door
54. Concept
55. Quatre + trois
56. Unruly rabble
57. Holiday preceder
58. Take-home amount

RECEIVED WISDOM

As Told To:
Benjamin Dane

Hotelier and designer LIZ LAMBERT on community, regrets and finding her calling at a motel in Austin.

I was in law before I became a hotelier. For three years I worked at the Manhattan district attorney's office before I returned home to Texas in the mid-'90s to work for the attorney general in Austin. I began to frequent my local neighborhood bar, the legendary Continental Club, which sat directly across the street from a run-down 1930s seafoam-green motor court on South Congress: the San José Motel. I would look at it from the window at the end of the bar and dream about what it could be. One day, I walked across the street and asked if they'd ever consider selling. As it turns out, the

KINFOLK

owner was planning to list it for sale in the local Asian weekly newspaper.

I knew nothing about renovating or running a hotel, but everything about it was compelling to me. I convinced my mother to cosign a bank loan to buy the San José, thinking I could upgrade it room by room—boy, was I wrong. If I knew then what I know now, I'm not sure I would have embarked on such an ambitious project that I knew nothing about, but I wouldn't trade it for anything. It changed my life, and I found my calling.

I've always thought of hotels as community centers; I wanted to create places where people came together. I grew up in West Texas, where my grandfather was a cattle rancher. He would read the newspaper and take meetings in the lobby of the Lincoln Hotel in downtown Odessa, or get his hair cut and boots shined in the shops off the lobby. I loved to go with him, to sit on the big leather sofas in the center of this hive of human activity, where business deals were done and people were coming and going with purpose or at leisure. My mother loved hotels, too—the Waldorf in New York City, La Fonda on the Plaza in Santa Fe, the Adolphus in Dallas, Hotel Texas in Fort Worth where, as she waited for her room to be ready, she heard JFK speak in the parking lot and shook his hand before he traveled to Dallas the day he was shot.

The best decision I ever made was to have a kid with my wife, Erin. Lyndon, who is about to turn six, has upended my world completely, in the very best way. On the other hand, if I could redo any moment in my life, it would be selling a majority of the hotel company I founded and trusting in the leadership of the bigger company.[1] It ended very badly for me and separated me from so much of what I had spent years building. I hate that I decided to trust in that situation—it still brings me deep sadness. But then, I wouldn't be where I am, doing the things I love with these people I love—so how could I ever really redo a thing? I'm a big believer that every bit of what happens leads us to where we are now, and I'm really happy about where I am now. Buy the ticket, take the ride.

(1) Lambert founded Bunkhouse Group, the company behind some of Austin's most iconic boutique hotels. Standard International acquired a 20 percent stake in Bunkhouse in 2014, eventually increasing its ownership to 51 percent by 2022, the same year Lambert departed from the company.

TOP TIP

As Told To:
Precious Adesina

Speechwriters MARISA POLANSKY and KRISTINE KELLER on giving the perfect toast.

We started helping people with their speeches almost a decade ago. We were working in writing and editing jobs in New York and our friends began coming to us with anxiety about speeches they had to write. We realized that if the smartest, funniest and most capable people we knew were struggling, others must be, too.

Many believe the key to a memorable toast is to make sure you follow a fairly standard template: to thank certain guests, give advice and lead the party in raising their glasses. While that can be a good place to start, whatever you do should feel personal. The audience should learn something new about who the toast is about, for example—you can include anecdotes but keep it to one or two.

There are those who want to be utterly unique—in the States, people love to do songs or rap. But for most people, giving a normal speech will be enough: The tradition of toast-giving is ancient and there's a reason the classic method resonates. If you do decide to deviate from something straightforward, it should be as a break in your speech rather than to replace it entirely.

The most significant rule is that a toast should have a beginning, a middle and an end. It should take the audience on an emotional journey where they don't quite know where they are heading. We often say that people should both laugh and cry, but always consider your strengths—you don't suddenly need to become a comedian. Unless you are extremely funny and good at delivery, it should be more heart than humor. (If you do include a heartfelt moment, make sure to read that part a little more slowly.)

Ultimately, it's about understanding who you are (and who the honoree is) and making it authentic. And remember, whether you're giving a toast at a wedding or a birthday party or on New Year's Eve, everyone will be rooting for you.

BEHIND THE SCENES

Words:
Sala Elise Patterson

TARINI MALIK, curator

In addition to organizing the practical and logistical aspects of an art exhibition, Tarini Malik's work as a curator involves confronting such topical issues as representation in art and postcolonialism. For this, she credits pioneering curators including Gaëtane Verna, the executive director of the Wexner Center for the Arts in Columbus, Ohio, and the artist John Akomfrah for paving the way, establishing a cultural landscape that's open to women and people of color like her. Their work (and hers) has paid off. After several top gigs in London—as a curator at the Whitechapel and Hayward Galleries, and the head of exhibitions for artist Isaac Julien—Malik was chosen to oversee Akomfrah's exhibition for the British pavilion at the 2024 Venice Biennale.[1] Verna, her mentor, happened to be curating the Canadian pavilion next door—a full circle moment that Malik says nearly brought her to tears of gratitude.

SALA ELISE PATTERSON: How did you come to be a curator?

TARINI MALIK: I was lucky to go to a school that offered art history as a subject, and that education drew me to galleries and museums as a young person. I began to see that there were stories being told that didn't necessarily reflect my own experiences as someone diasporic. The desire to see these institutions reflect the complexity of the life and identity I embody led me to curating.

SEP: What's the role of a curator?

TM: Curators are in service to an artist, to an exhibition space and to the audience. Your role is to be a custodian of an artist's ideas and work, and to think about how best to present them within the institution that you're occupying.

SEP: How has that role evolved over time?

TM: Over the last 10 years, we've seen a contraction of the arts where funding isn't what it was, where it's harder for younger artists to work. We've seen the closure of important radical experimental spaces. We've seen artists having to move out of cities and work in different industries to support their practices. We've seen arts education come under threat. Curating has become more

expansive as a result. We have to be more nimble and forward-thinking in aspects of the practice like fundraising or having a hand in the art market. We also have to champion different kinds of partnerships, like relationships with corporates and brands. It's tough to be a young curator today.

SEP: How did you approach the project with John Akomfrah for the British pavilion at the Venice Biennale?

TM: We created *Listening All Night to the Rain*, which explores histories of migration, climate, colonialism and the diaspora. It draws on archives and narratives from all five continents, looking at stories that have been excluded, underrepresented and marginalized. It was an ambitious project: eight multi-screen sound and video installations, occupying more space [in the British pavilion] than has ever been occupied. In our first conversation John said, "Tarini, it's about taking up space, quite literally. You and I are there to take up space and to be seen and heard." Both of us were born in ex-colonies of the British Empire—John in Ghana, and me in India. So, for us, this was very much about trying to dismantle and embody some of the complex histories that were part of the pavilion and the site of the Biennale. It was our way of showing the ability of art to hold multiple narratives in one space.

SEP: How do you see the role of a curator evolving in the future?

TM: I would love to see more equitable paths into the profession. When I was starting out, there weren't many teachers who looked like me or who were interested in global majorities and in coloniality. But of course, they exist. And I think the future of curating lies in those voices.

(1) The Giardini della Biennale in Venice houses 30 permanent national pavilions. The pavilions are the property of the individual countries and are managed by their ministries of culture to showcase their country's artists during the prestigious arts festival, which is held every two years.

KINFOLK

SEASONAL PRODUCE

As Told To: Apoorva Sripathi

Chef, urban farmer and food campaigner TARA THOMAS shares a hearty winter recipe.

Sweet potatoes might not be as malleable as regular potatoes but they are an accessible staple that is both nutrient-dense and flavorful. And like other winter vegetables, you don't have to eat them right away—you can stock up and use them as needed.

This comforting and hearty shepherd's pie uses mashed sweet potato for the topping and lentils cooked with warming spices instead of meat. If you don't have sweet potatoes on hand, you can use a winter squash mashed with regular potatoes, and for a vegan option, just swap out the butter, milk and cheese for the nondairy alternatives, and use the homemade Worcestershire sauce option.

It's the perfect pie for meal planning, especially in the winter and the holiday season, when we're gathering in a more intentional way. Make it in advance and eat it over a day (or two or three) by the slice, like cake, whenever you want.

SERVES 4 (WITH SECONDS)

For the sweet potato topping:
Salt
1½ to 2 pounds (680 to 900g) sweet potatoes
8 tablespoons (115g) salted butter or nondairy option, at room temperature
⅓ cup (75ml) barista-style nondairy milk or half-and-half
½ teaspoon onion powder
Ground black pepper
2 tablespoons nutritional yeast or Parmesan cheese

For the lentil stew:
2 tablespoons salted butter or nondairy option
2 bay leaves
1 tablespoon ground coriander
½ teaspoon ground cumin
½ teaspoon paprika
2 cups dried red split lentils
1 teaspoon chopped fresh parsley leaves
1 teaspoon chopped fresh rosemary leaves
1 teaspoon chopped fresh thyme leaves
½ teaspoon salt
½ teaspoon ground black pepper
2 medium carrots, diced
3 tablespoons Worcestershire sauce[1]
2 garlic cloves, minced
2 tablespoons all-purpose or gluten-free flour
2 tablespoons tomato paste
2 tablespoons vegetable broth base
4 cups (1L) boiling water
1 tablespoon red wine
1 cup frozen peas or chopped fresh snap peas

To make the sweet potato topping: Bring a large pot of salted water to the boil and add the sweet potatoes to the pot. When they are tender and easily pierced with a fork, drain, allow to cool and remove the skins. Transfer to a bowl and mash until smooth, folding in the butter, milk, onion powder, ½ teaspoon of salt and ¼ teaspoon of pepper. Add the nutritional yeast, taste and adjust the seasonings, and set to one side.

To make the lentil stew filling: Heat a medium pot over low heat and add the butter and the bay leaves. Once aromatic, add the coriander, cumin and paprika and mix well. After a minute or so, add the lentils and cook for five minutes, stirring occasionally. Add the parsley, rosemary, thyme, salt, pepper and carrots, mix well and cover for a few minutes until the carrots are vibrant. Add the Worcestershire sauce and garlic, stir to combine and cook for about a minute before adding the flour, tomato paste and broth base. Stir until well incorporated and there are no clumps before pouring in the boiling water and wine. Bring to a boil then reduce to a simmer for 15 to 20 minutes. Once cooked into a thick stew, remove the bay leaves and stir in the frozen peas. Then set aside and preheat the oven to 400°F (200° C).

In a 9-by-9 or 7-by-11-inch baking dish, spread the lentil stew into an even layer. Spoon the mashed sweet potato on top, spreading carefully, and drag a fork across the top to add texture and allow the mash to get crispy. Bake until golden on top, about 25 to 30 minutes. Cool for 15 minutes before serving.

(1) To make homemade Worcestershire sauce, mix 2 tablespoons soy sauce, 1 teaspoon brown sugar or coconut sugar, and 1 tablespoon red wine vinegar.

CREDITS

A.G. COOK COVER:	PHOTOGRAPHER	Emman Montalvan
	SET DESIGNER	Kelly Fondry
	STYLIST	Carlee Wallace at Art Department LA
	STYLING ASSISTANT	Boyd Sloan
	GROOMER	Nicole Maguire at TMG Agency
	PHOTO ASSISTANTS	Justin Brooks & Patrick Molina
	DIGITAL TECH	Alex Woods

Cook wears a sweater by Martine Rose.

PARTY COVER:	PHOTOGRAPHER	Annika Kafcaloudis
	STYLIST	Stephanie Stamatis
	MODEL	Jett Bolt at People Agency

A.G. COOK:	STYLING ASSISTANT	Boyd Sloan
	PHOTO ASSISTANTS	Justin Brooks & Patrick Molina

SPECIAL THANKS:		Rikke Bødker Christensen at Reform
		Anne Mette Müller-Krogstrup

STOCKISTS: A — Z

—	&DRAPE	anddrape.com
A	ACNE STUDIOS	acnestudios.com
	AGMES	agmesnyc.com
	ALECTRA ROTHSCHILD / MASCULINA	iwantmasculina.com
	AMALIE GRAUENGAARD	amaliegrauengaard.dk
	ANDREW'S FORMALS	andrewsformals.com
B	BLÆS	blaes.dk
C	CAROLE TANENBAUM	caroletanenbaum.com
	COMMON PROJECTS	commonprojects.com
	COPERNI	coperniparis.com
	CORALI	corali.jewelry
	CORDIUS GLAS	cordiusglas.dk
	COS	cos.com
D	DAVID MELLOR	davidmellordesign.com
	DE GOURNAY	degournay.com
E	ECKHAUS LATTA	eckhauslatta.com
	EDWIN	edwin-europe.com
	ERL	erl.store
F	FLATLIST	flatlisteyewear.com
	FREYA DALSJØ	freyadalsjo.com
G	GUCCI	gucci.com
H	H. SKJALM P.	hskjalmp.dk
	HAY	hay.dk
	HELLE MARDAHL STUDIO	hellemardahl.com
	HERMÈS	hermes.com
	HOUSE OF FINN JUHL	finnjuhl.com
I	IVAN GRUNDAHL	studiogrundahl.com
J	J.LINDEBERG	jlindeberg.com
	JOE CHRISTOPHERSON	@christopherson_joe_ceramic
K	KARAKTER	karakter-copenhagen.com
	KILIAN KERNER	kilian-kerner.de
	KRÆSS	kraess.dk
	KRISTINE VEDEL ADELTOFT CERAMICS	kristinevedeladeltoft.dk
L	LOUIS POULSEN	louispoulsen.com
	LOUISE ROE	louiseroe.dk
M	MARSET	marset.com
	MARTINE ROSE	martine-rose.com
	MASSIMO COPENHAGEN	massimo.dk
	MFPEN	mfpen.com
	MONTANA	montanafurniture.com
N	NATALIA CRIADO	nataliacriado.com
	NEMO LIGHTING	nemolighting.com
	NICKLAS SKOVGAARD	nicklasskovgaard.com
	NINA NØRGAARD	ninanorgaard.com
	NORMANN COPENHAGEN	normann-copenhagen.com
O	OFFICINE CREATIVE	officinecreative.store
	OMEGA	omegawatches.com
	ØRSKOV	orskovcopenhagen.dk
P	PHILIPPE MODEL	philippemodel.com
R	REFORM	reformcph.com
	RICHARD MILLE	richardmille.com
	ROLEX	rolex.com
S	SIMON MANOHA	simonmanoha.com
	STILLEBEN	stilleben.dk
	STINE GOYA	stinegoya.com
	STOCKHOLM SURFBOARD CLUB	stockholmsurfboardclub.com
	STRAND32	@strand32_secondhand
	STRING	stringfurniture.com
	SZKLO STUDIO	szklo.studio
T	TADAIMA	tadaimacph.com
	THEO	iwanttheo.com
	TINA FREY	tf.design
V	VALERIE_OBJECTS	valerie-objects.com
Y	YONOBI	yonobi.com

POINT OF VIEW

As Told To:
Hannah Marriott

Photographer SCOTT SCHUMAN on his favorite corner in Milan.

I'm standing at the intersection of Corso Venezia and Via Senato, near my house in Milan. It's a summer evening. People are walking or riding their bikes home from work. Each corner offers a different backdrop: People drink Campari spritz outside Princi bakery. The sun shines on the beautiful old facade of Palazzo Serbelloni. Across the road is Armani/Casa, a darker, modern building where they know me so well that they invite me inside whenever it rains. I come to this corner a lot. It has started to feel like my office.

I've been doing street-style photography as The Sartorialist for 20 years. Usually, I will get four or five successful shots on a really good day. But when I started shooting at this corner, by chance, while waiting for a light to change, in June 2023, I was surprised. I got two good shots in quick succession, then eight more within two hours. It helps that there is a lot of movement here, with so many people biking. The wind in someone's hair as they cycle makes for a great image, and in the summer, when everyone is tan, there are many summer dresses. Italy is very seasonal. It's about eating the right food at the right time. This is a summer corner.

Milan always struck me as somewhere romantic and mysterious when I was growing up in Indiana in the 1980s, falling in love with fashion from afar. Later, I got the chance to work here and I was wowed. It was much more livable than I had expected. When my kids were older, a little after the pandemic, I decided to move here.

The architecture says so much about this city. I'm working on a book about Milan with Taschen for fall 2025, which will capture the beautiful buildings as well as the style. There are incredible villas, tiny Versailles hiding behind plain facades; so many beautiful metal gates, which sit behind the huge wooden doors that conceal the famous Milanese courtyards. It is very Milan: When the wooden doors are open you can see the courtyards, but you still can't get inside.

Milan is more diverse than people think, but it's still very homogeneous. People feel they had better look their best. It's like in the old days when people used to say: *We had better dress up, we're going to New York*. Milan is still like that. Here, women want to look pretty, guys want to look handsome; in New York, people want to look tough. In Paris, they want to look sexy, but not as though they're trying too hard. In London it's quirky, it's "so bad it's good." But Milan still looks like Milan. I can see the difference.